NATIONAL PARKS
COLORING BOOK

Color Your Way Through
America's Treasured
Landmarks

chartwell
books

INTRODUCTION

They've been called America's best idea. Our national parks are places where everyone can enjoy the awe, majesty, and uniqueness of some of the country's most treasured landscapes. From the rugged desert vistas of the West to the serene grasslands of the Great Plains, America's national parks encompass some of the wildest, most beautiful terrain in North America. National parks belong to everyone, and a visit to one or more is a must. If you're a frequent national park visitor or are daydreaming of a future trip, this book is for you. Imagine a sunset over a painted desert or the lush green foliage of an evergreen forest. Picture snow-covered peaks and cascading waterfalls that will take your breath away. With more than 100 templates to inspire you, you can create picture-perfect images of these national treasures.

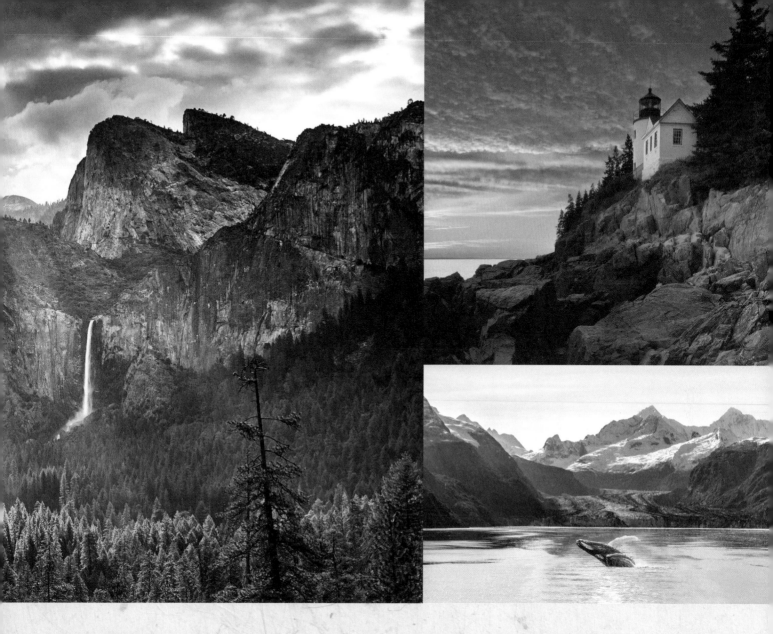

Coloring these engaging images from our national parks will take you on a journey. As you color, you can imagine the sights, sounds, and scents of the park you're recreating, letting your mind wander there. Relax into the dramatic scenery and make it as realistic or creative as you wish. Let the hours pass as you bring the parks colorfully to life.

Each piece of art is line drawn and ideal for colored pencil, marker, or gel pen. Mix your coloring media for interesting effects. Whether you're on a long road trip to a park, coming back from one, or dreaming of a future trip, this coloring book will help you to appreciate the unspoiled beauty of our scenic public lands

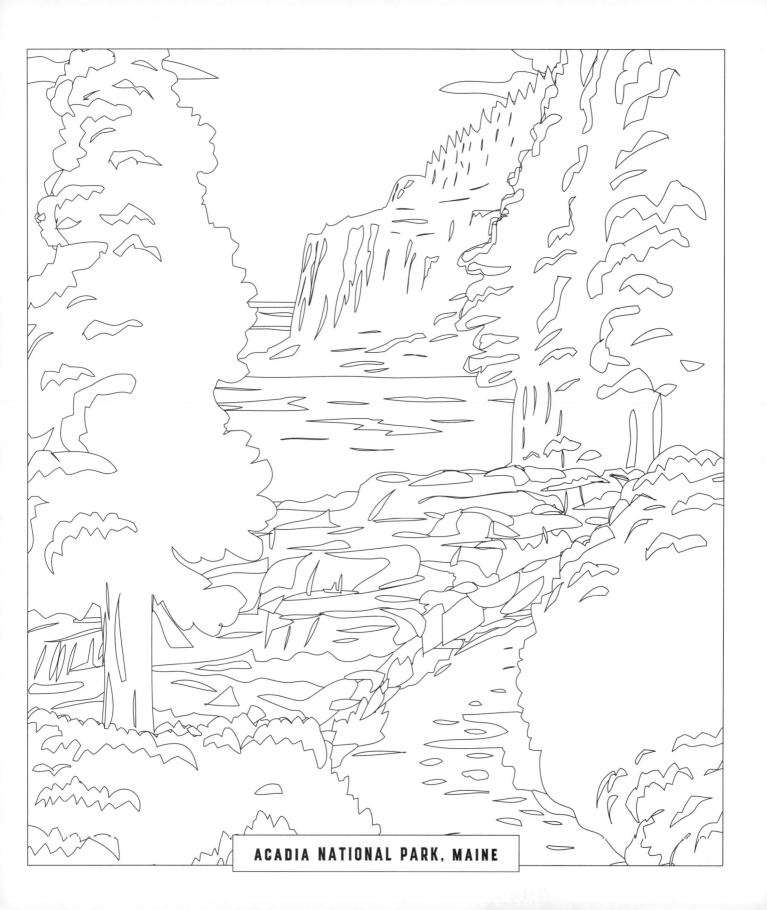

ACADIA NATIONAL PARK, MAINE

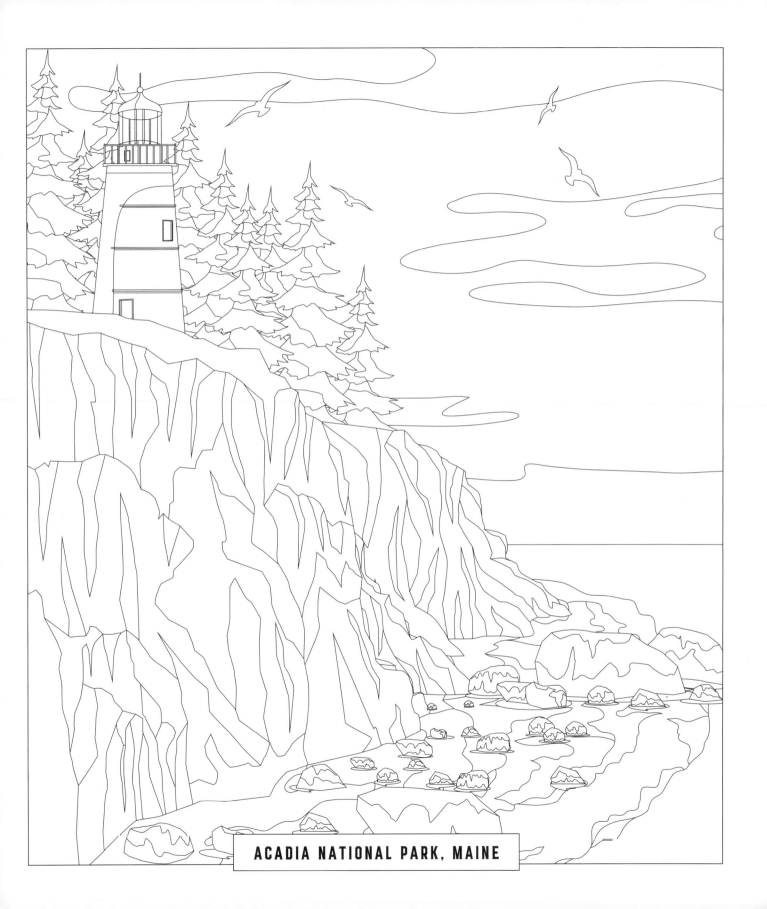

ACADIA NATIONAL PARK, MAINE

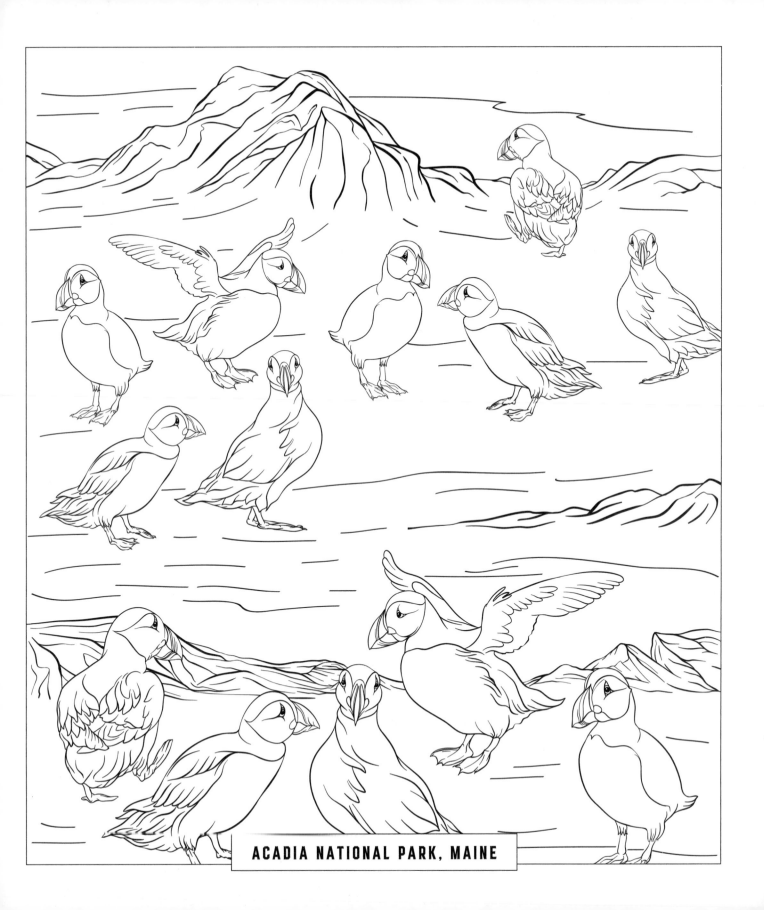

ACADIA NATIONAL PARK, MAINE

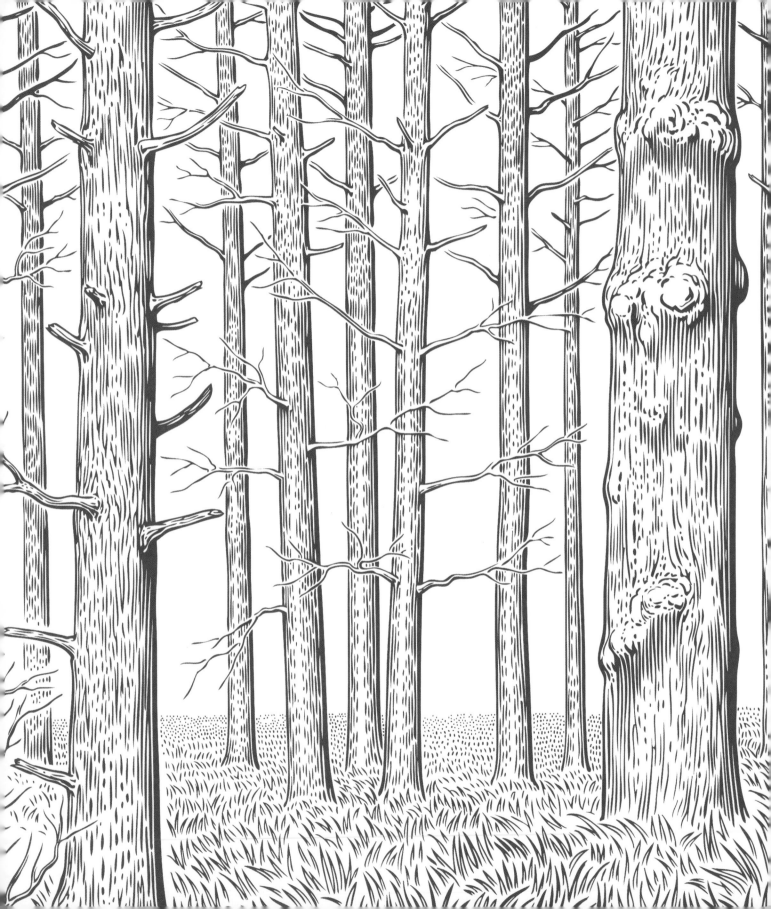

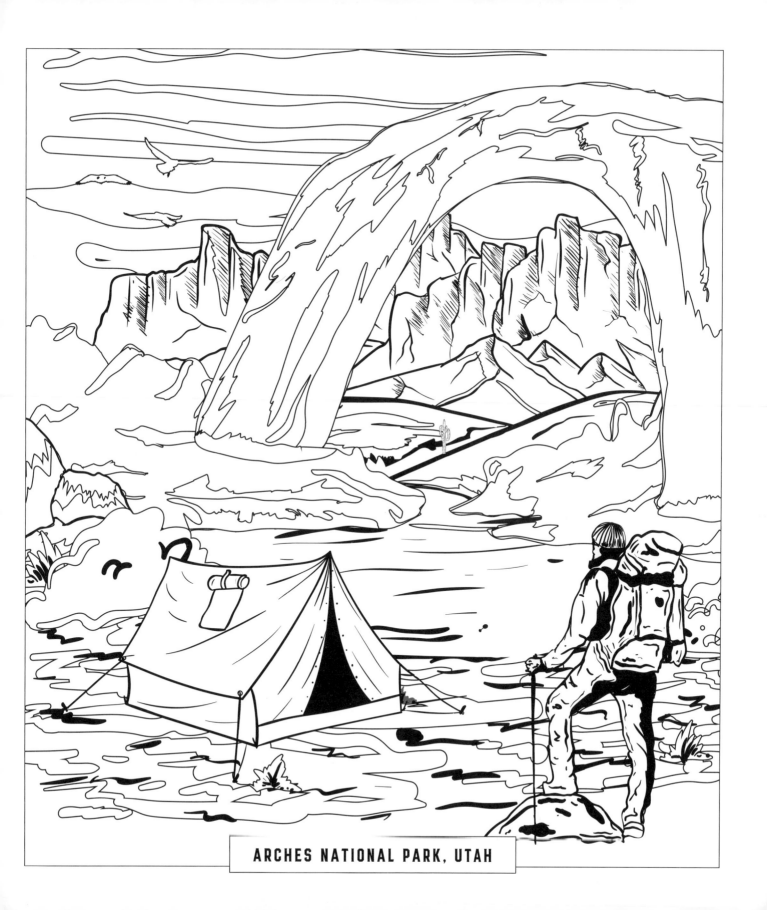

ARCHES NATIONAL PARK, UTAH

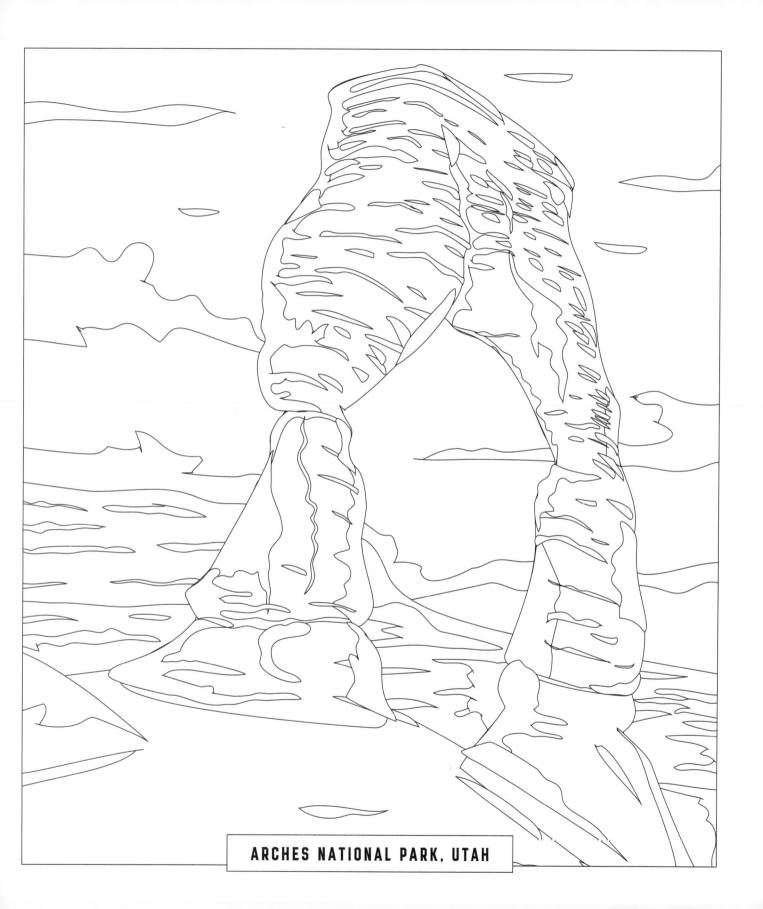

ARCHES NATIONAL PARK, UTAH

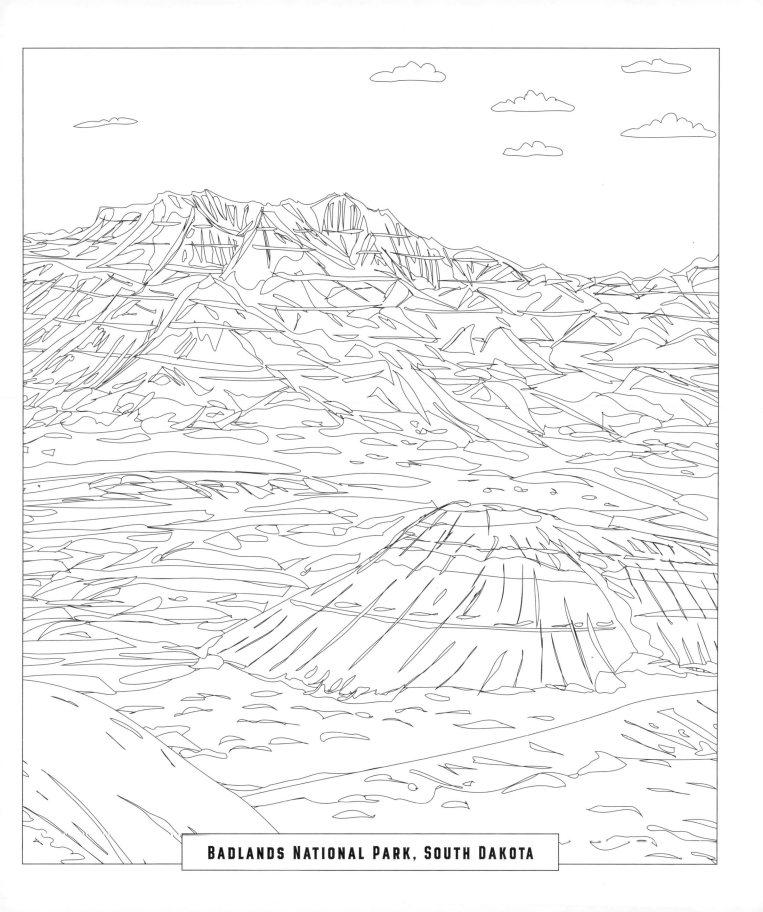

BADLANDS NATIONAL PARK, SOUTH DAKOTA

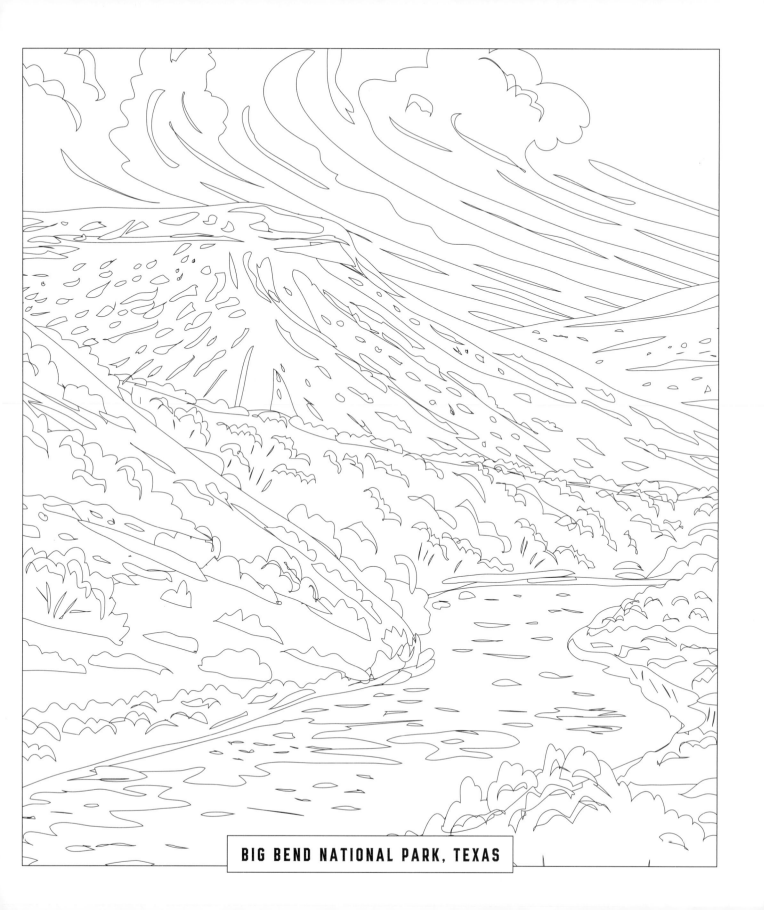

BIG BEND NATIONAL PARK, TEXAS

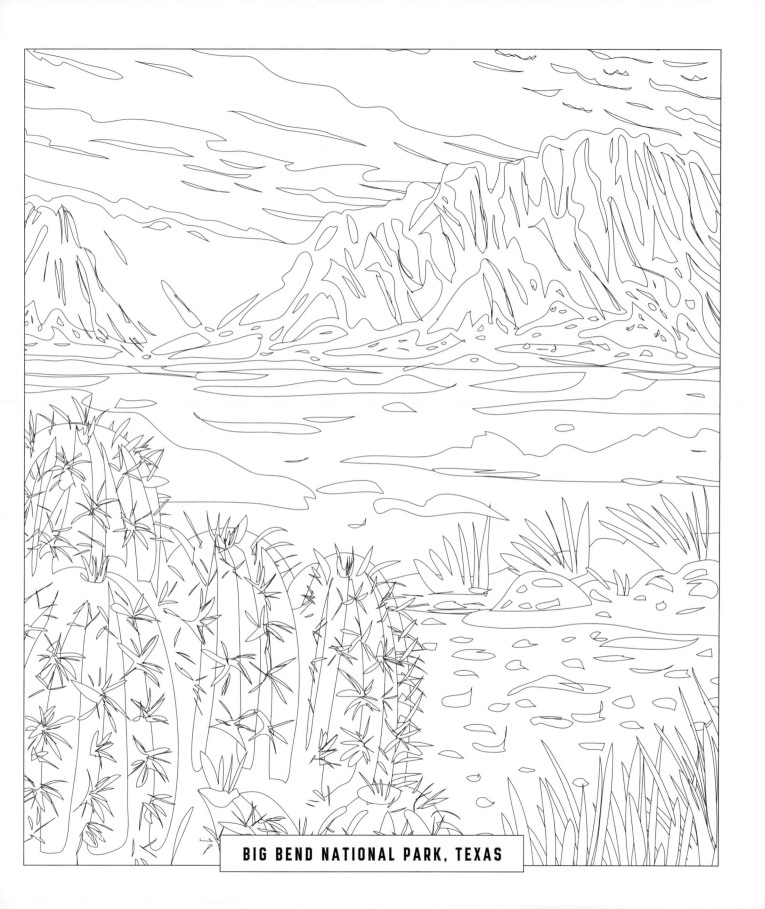

BIG BEND NATIONAL PARK, TEXAS

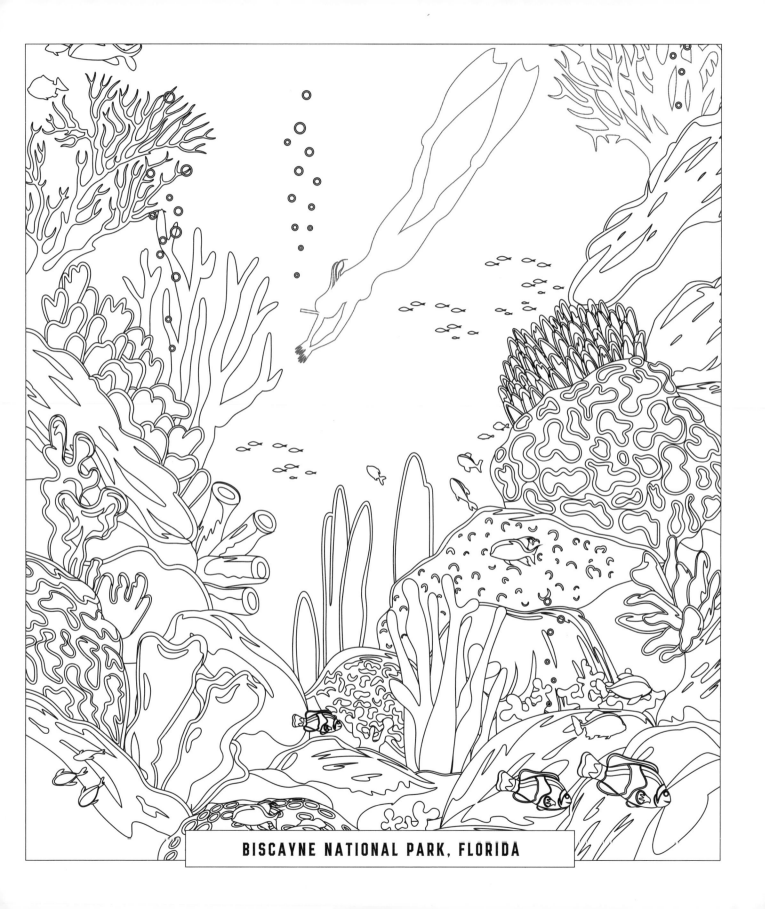

BISCAYNE NATIONAL PARK, FLORIDA

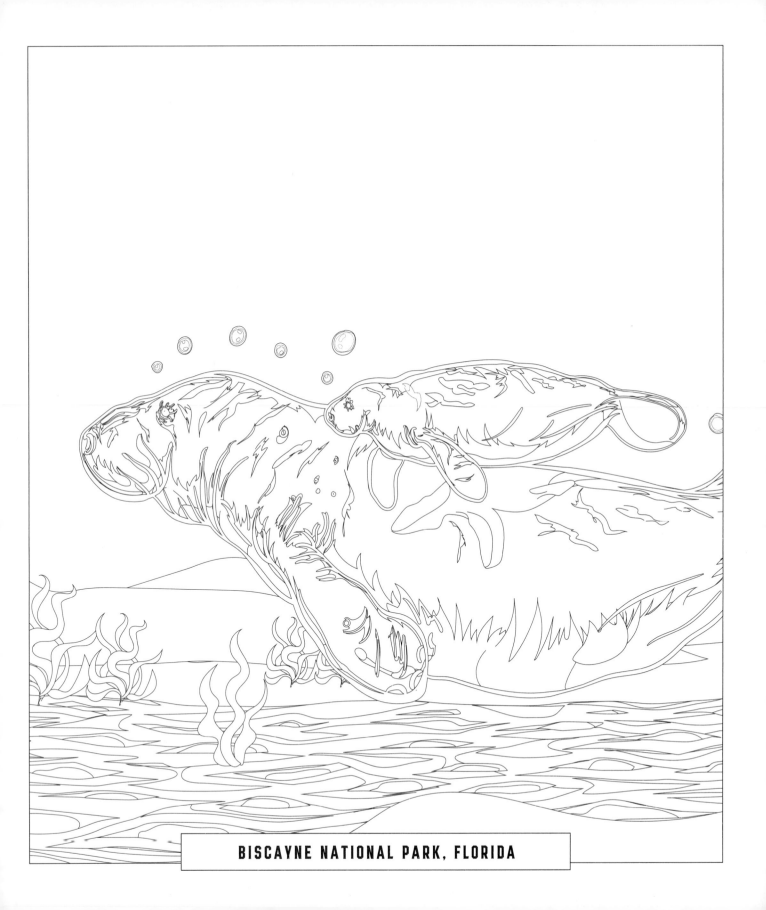

BISCAYNE NATIONAL PARK, FLORIDA

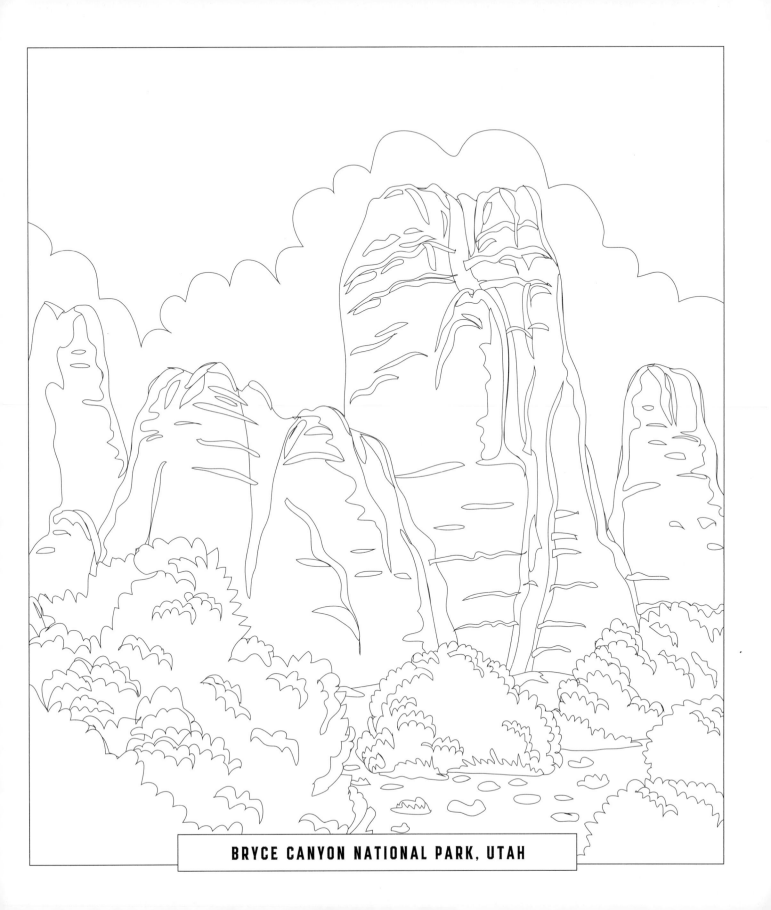

BRYCE CANYON NATIONAL PARK, UTAH

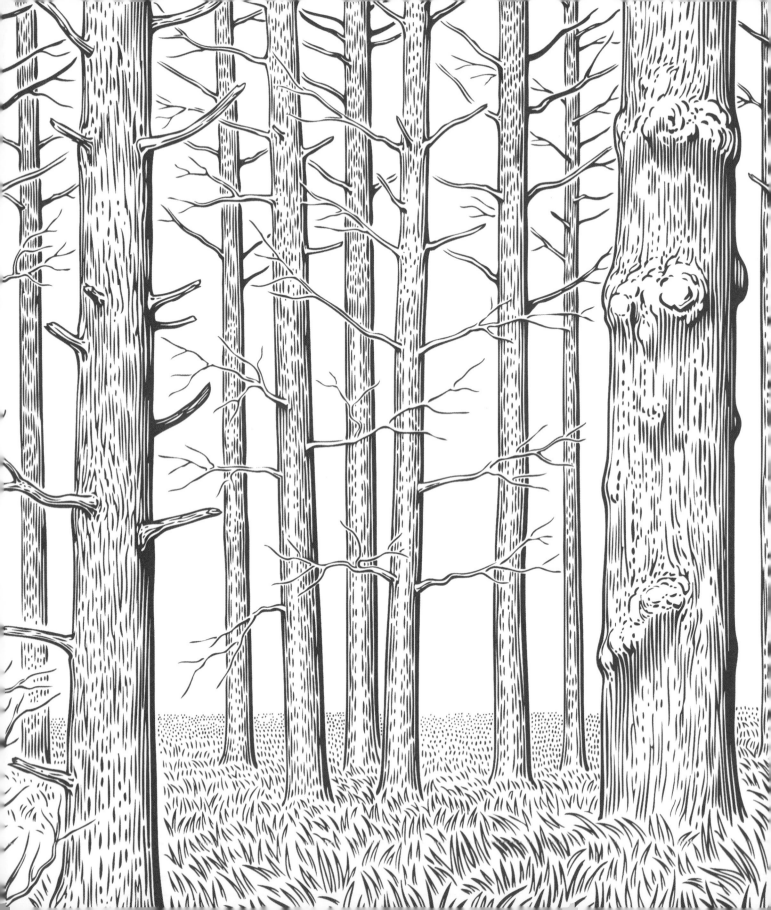

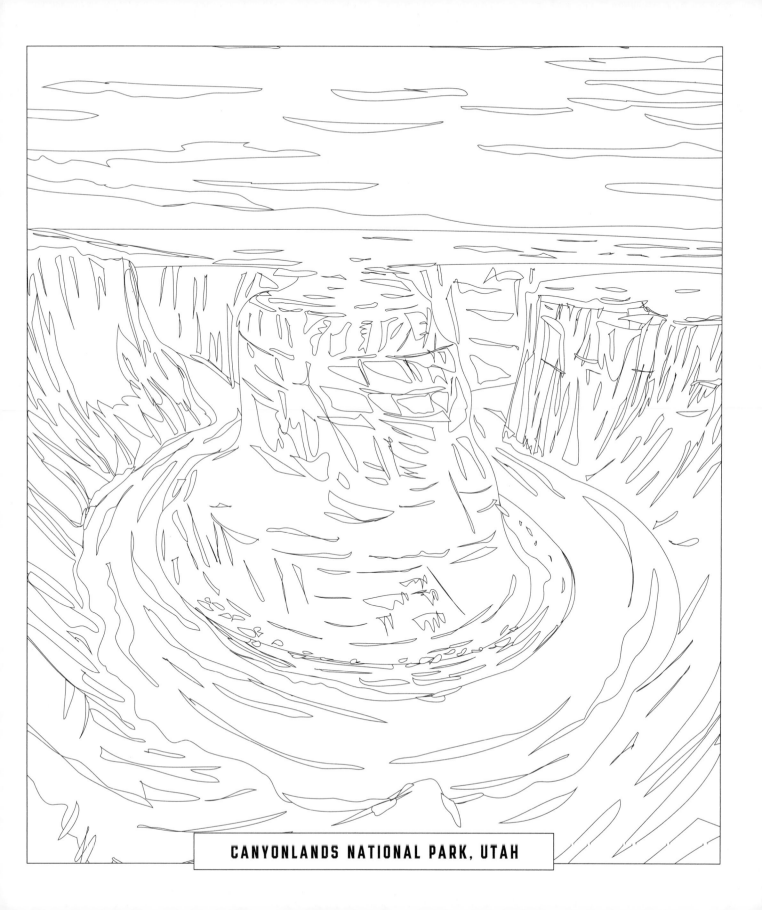

CANYONLANDS NATIONAL PARK, UTAH

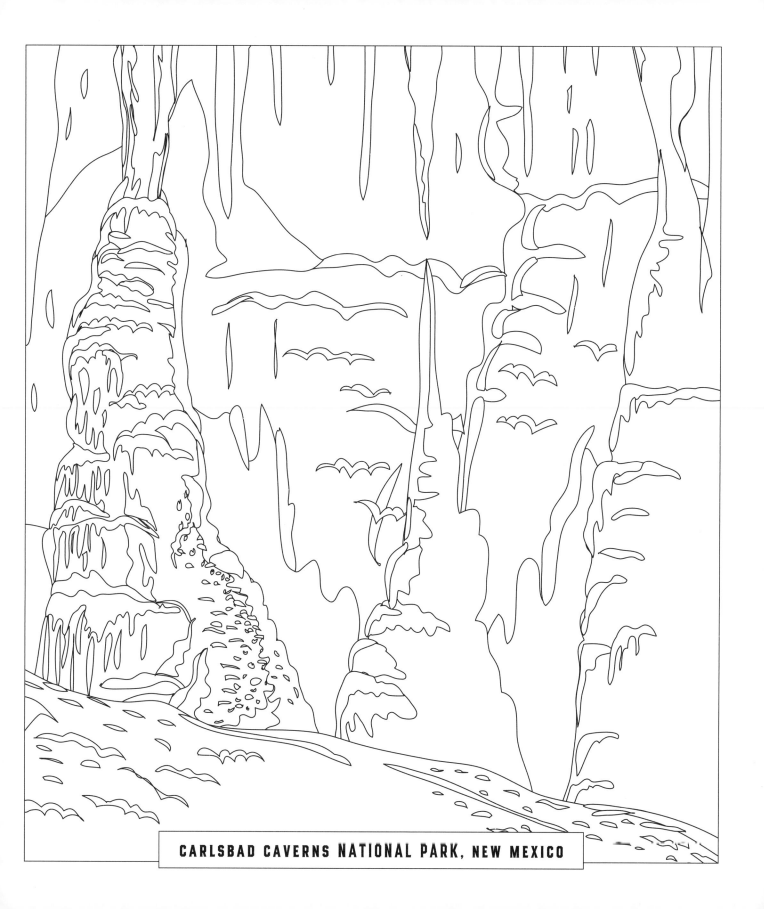

CARLSBAD CAVERNS NATIONAL PARK, NEW MEXICO

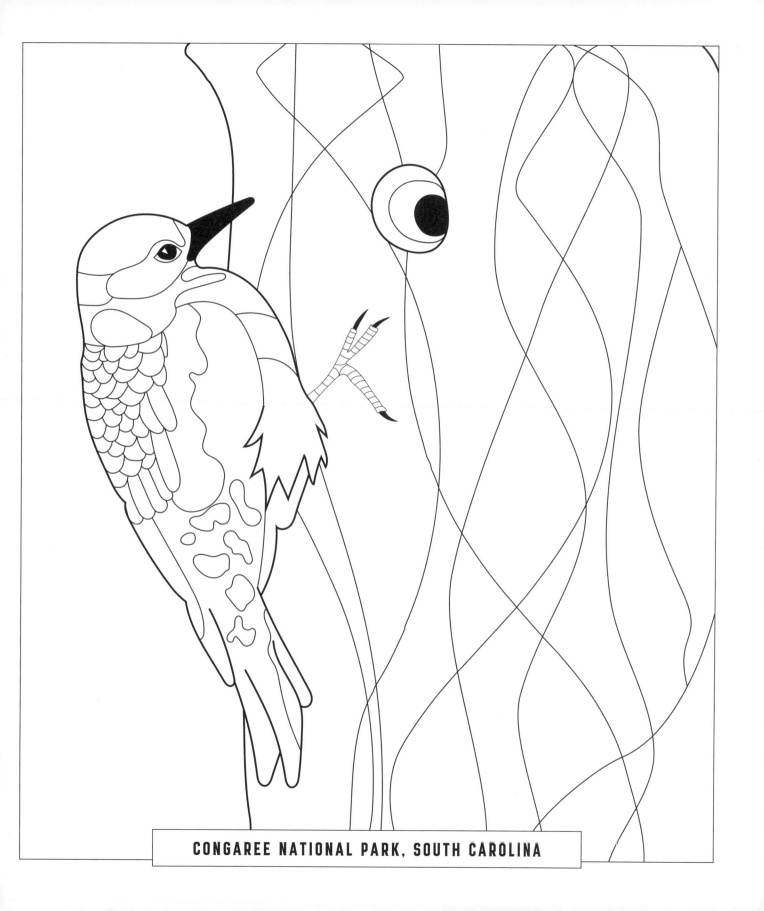

CONGAREE NATIONAL PARK, SOUTH CAROLINA

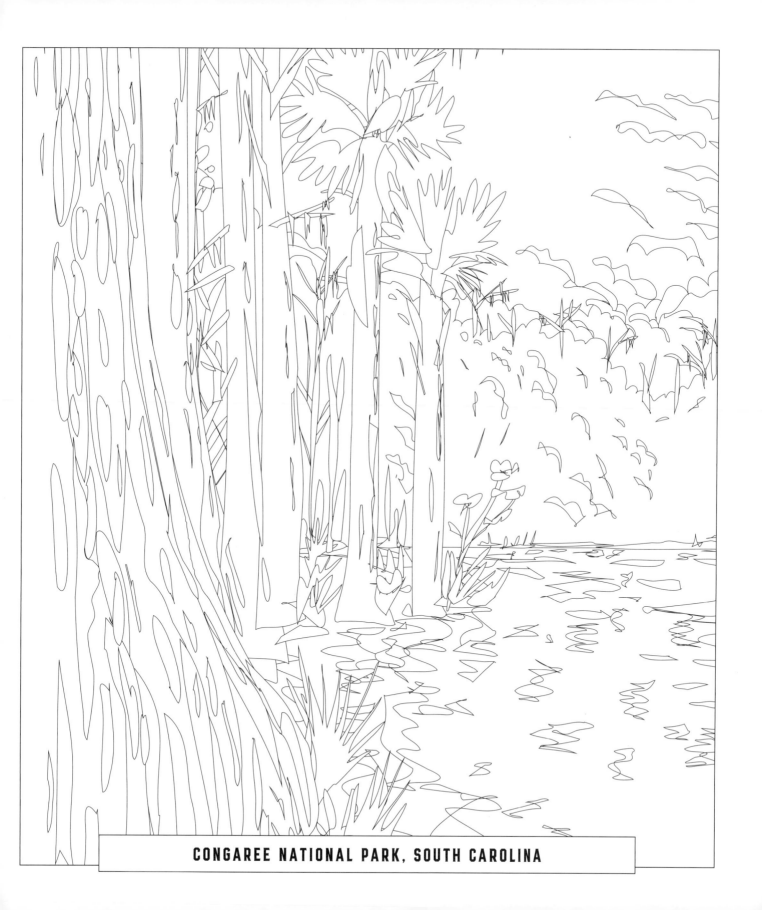

CONGAREE NATIONAL PARK, SOUTH CAROLINA

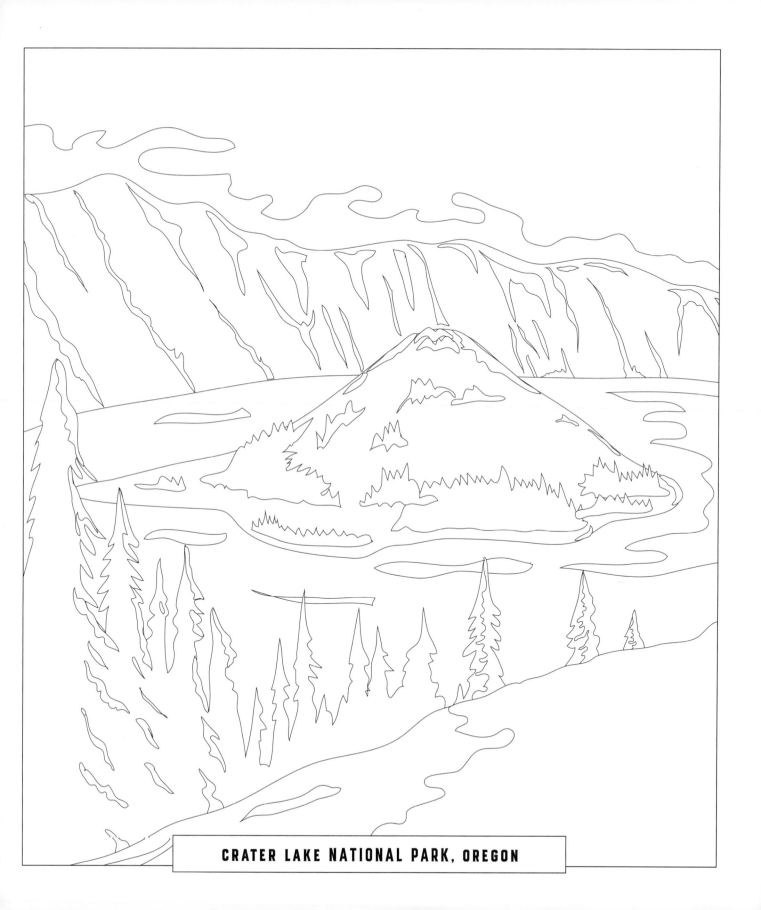

CRATER LAKE NATIONAL PARK, OREGON

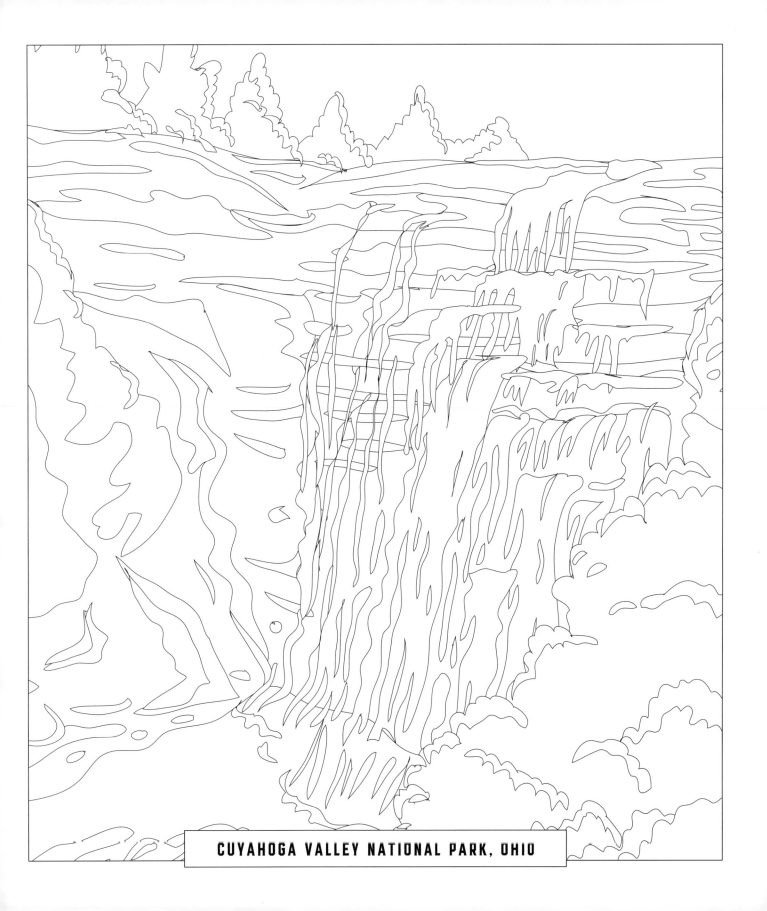

CUYAHOGA VALLEY NATIONAL PARK, OHIO

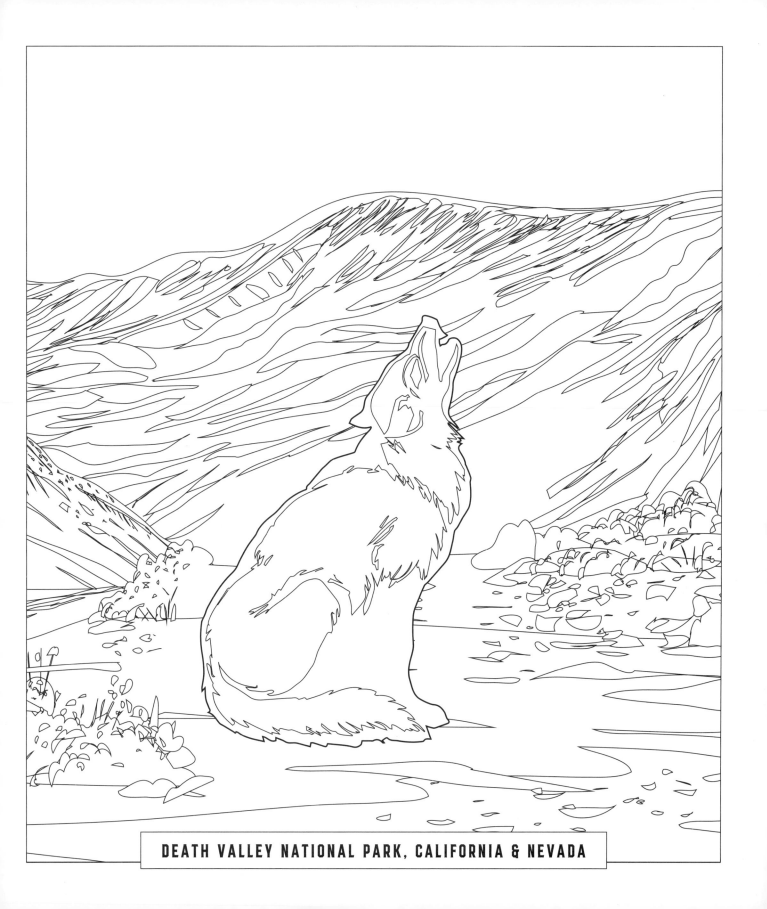

DEATH VALLEY NATIONAL PARK, CALIFORNIA & NEVADA

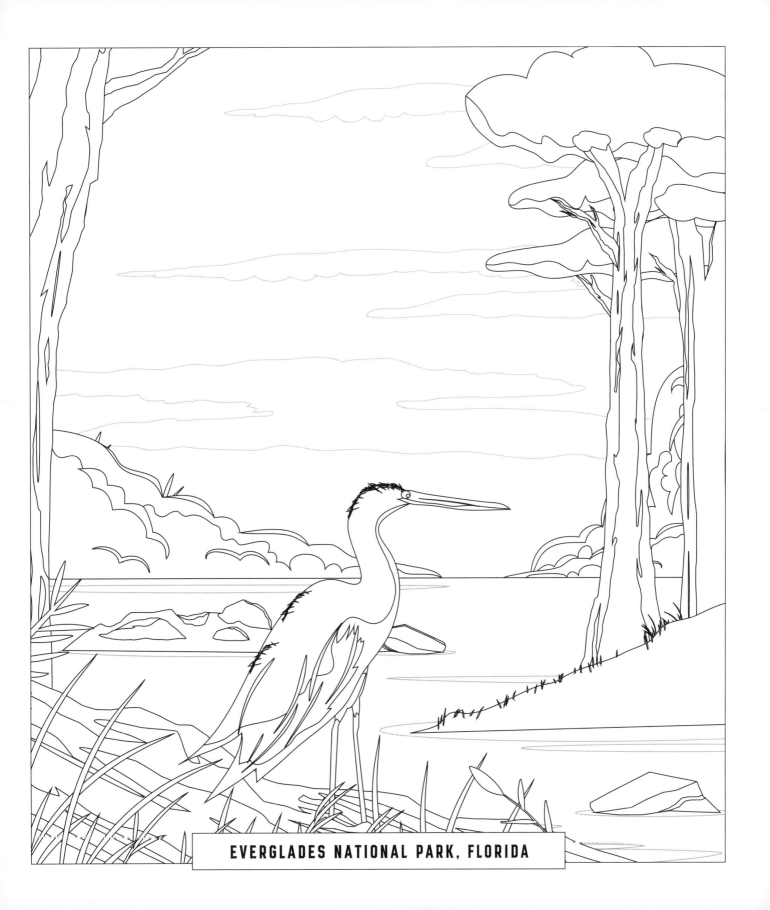

EVERGLADES NATIONAL PARK, FLORIDA

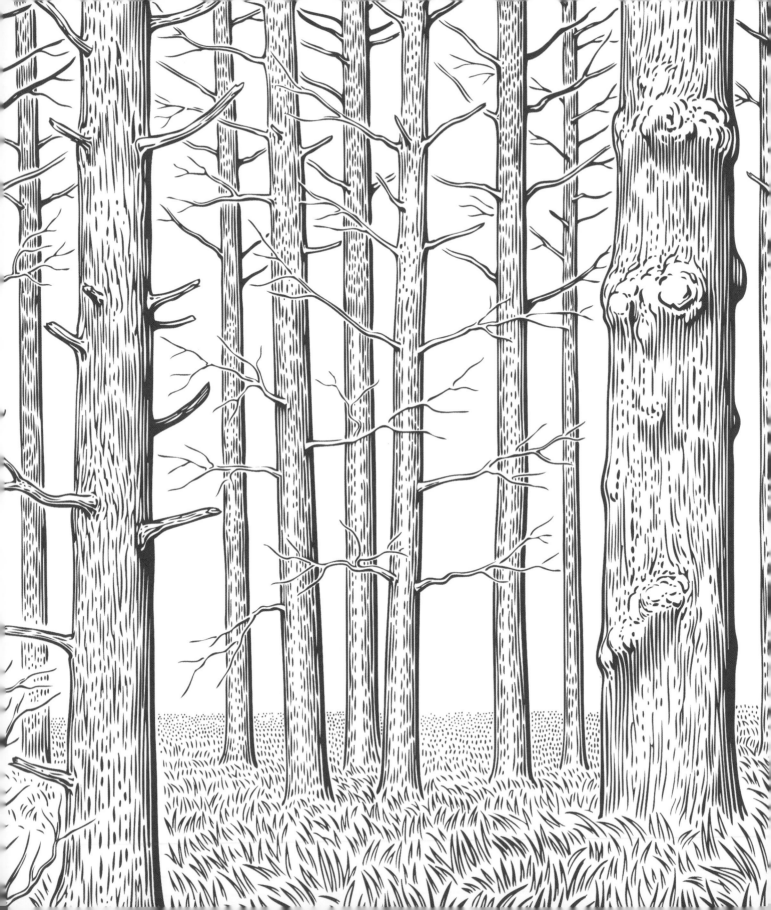

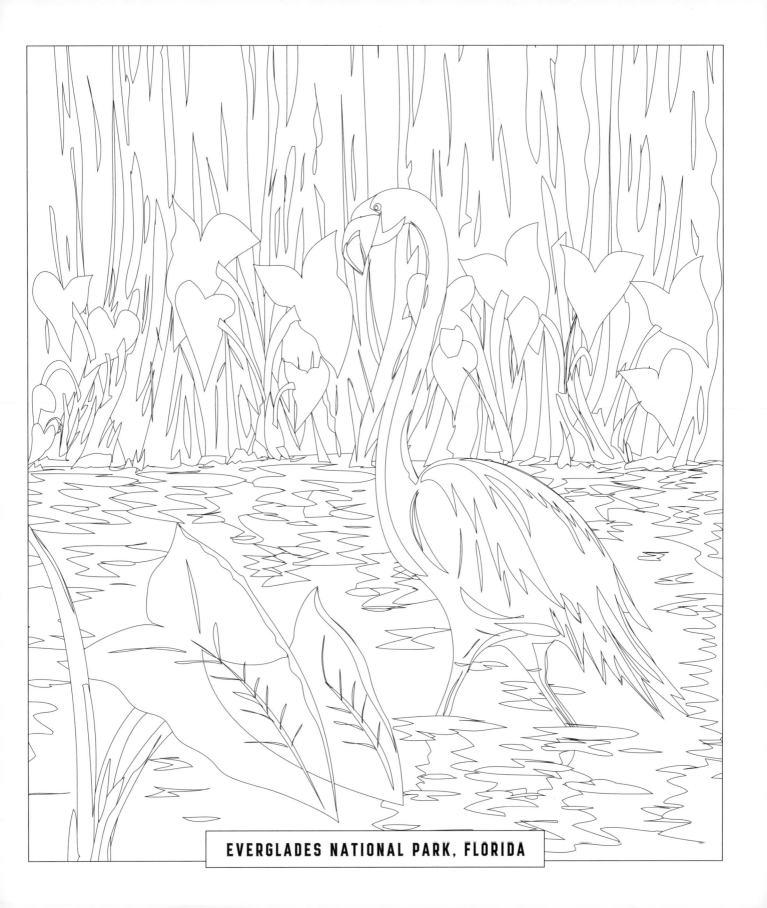

EVERGLADES NATIONAL PARK, FLORIDA

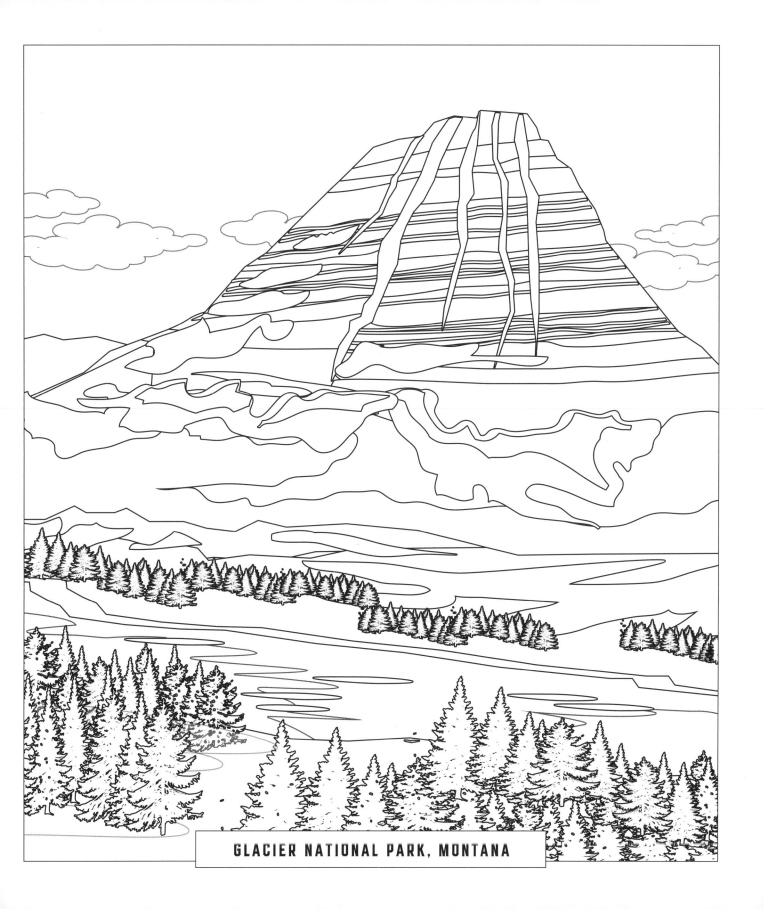

GLACIER NATIONAL PARK, MONTANA

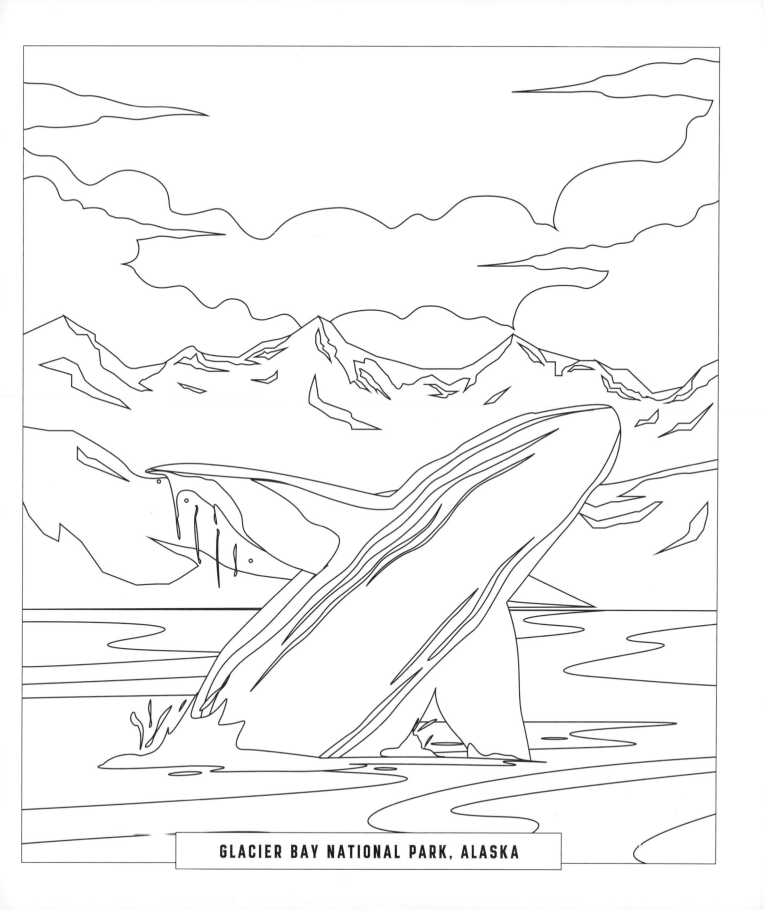

GLACIER BAY NATIONAL PARK, ALASKA

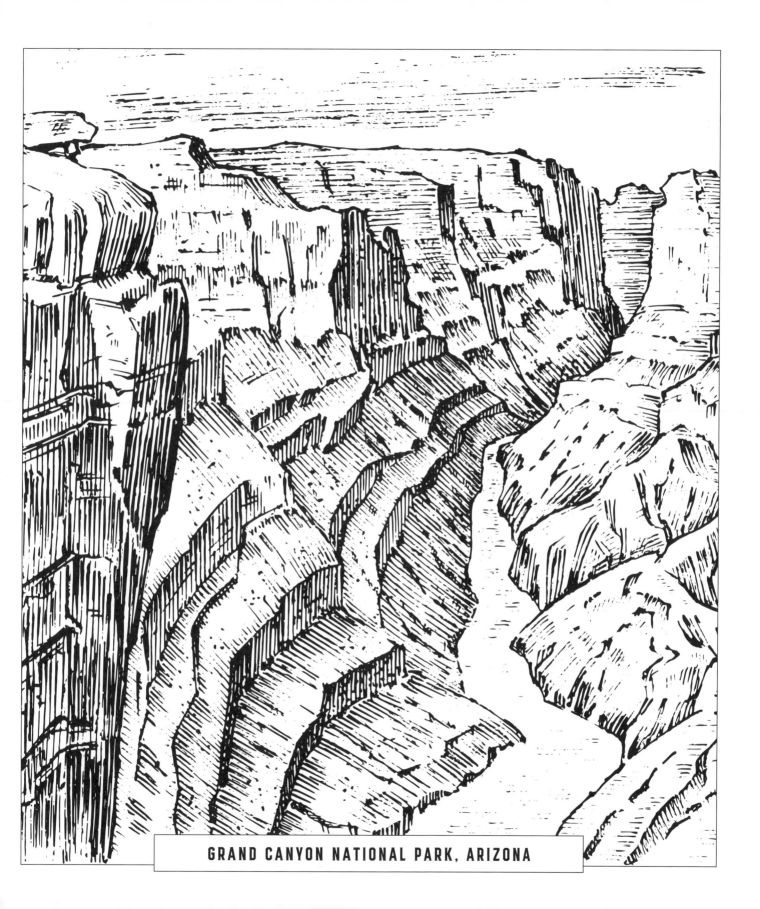

GRAND CANYON NATIONAL PARK, ARIZONA

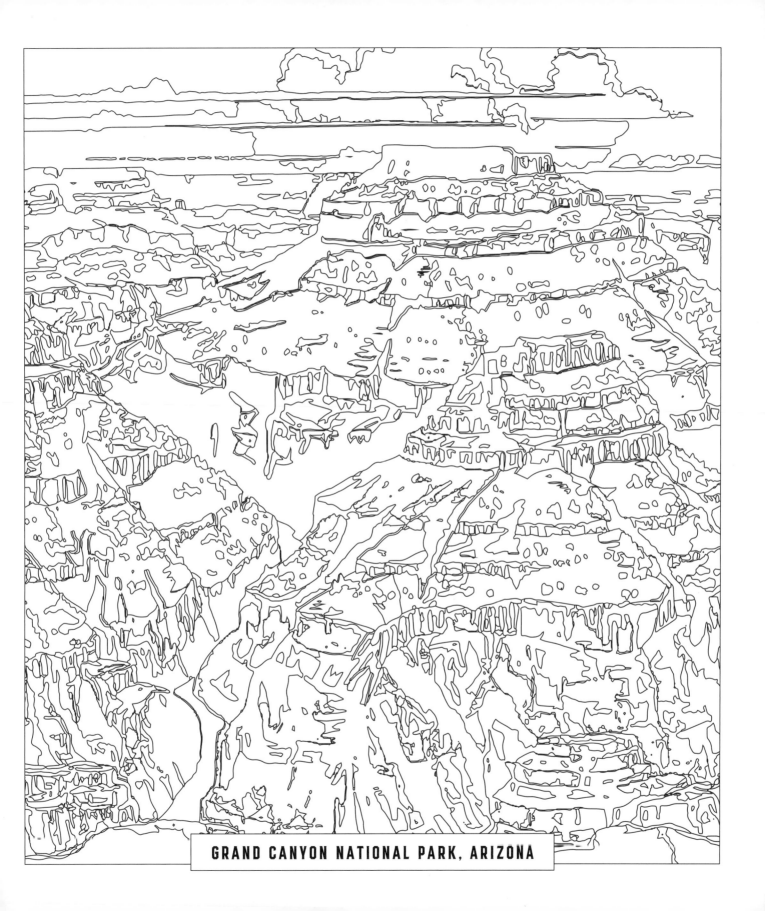

GRAND CANYON NATIONAL PARK, ARIZONA

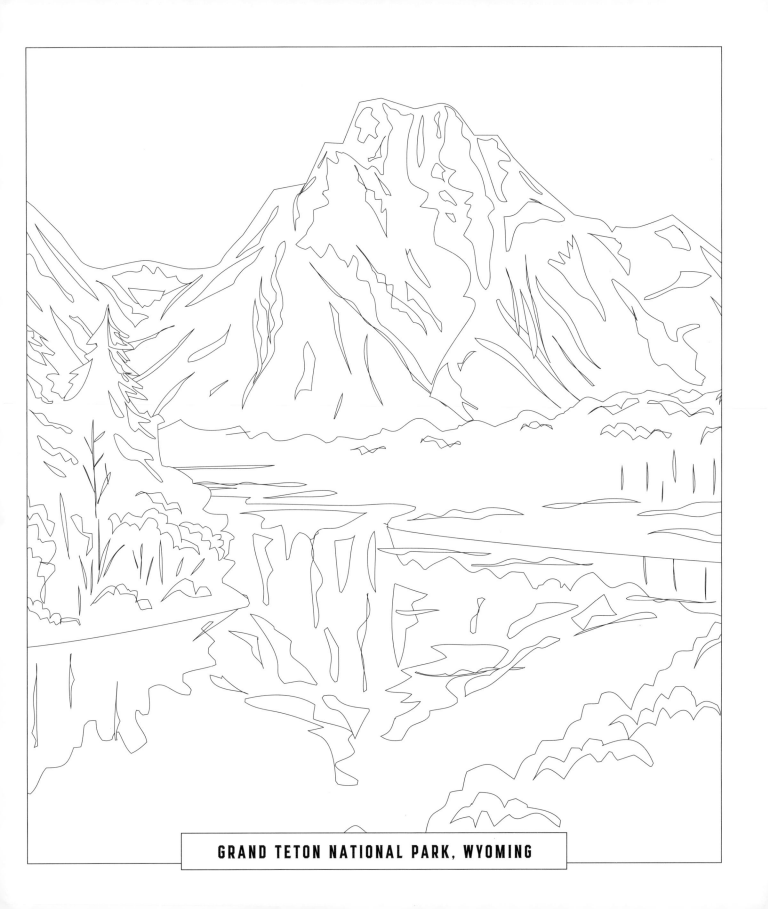

GRAND TETON NATIONAL PARK, WYOMING

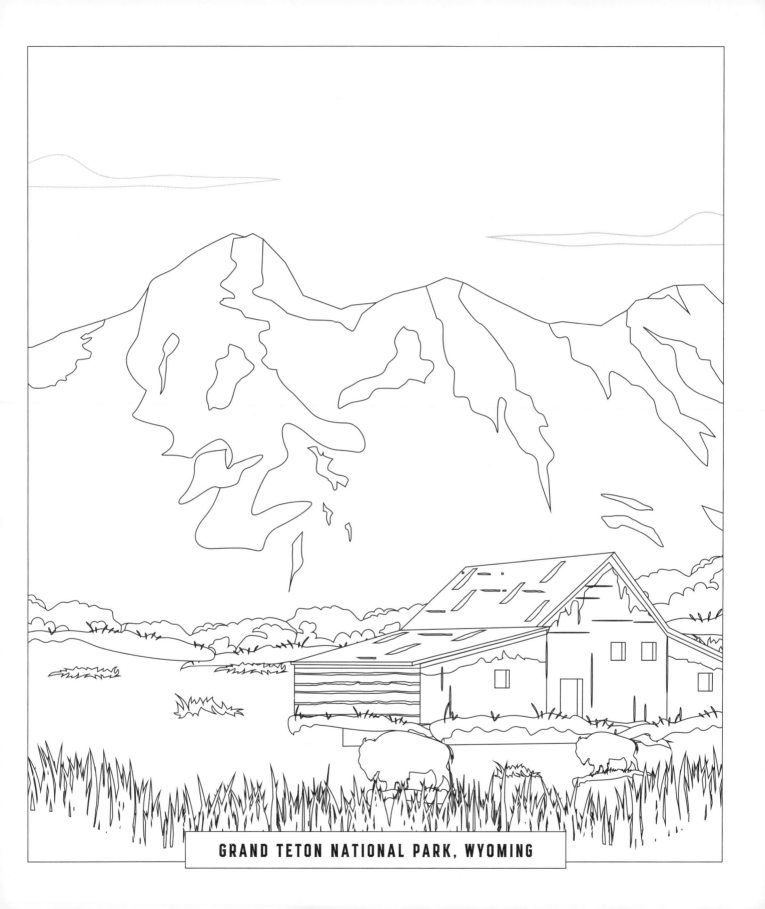

GRAND TETON NATIONAL PARK, WYOMING

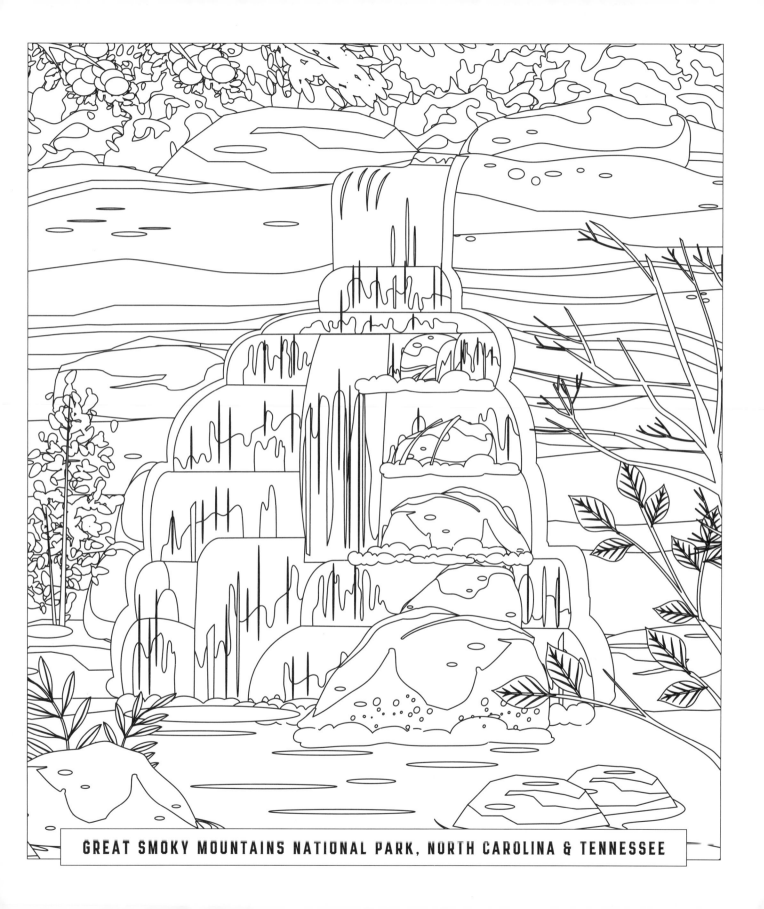

GREAT SMOKY MOUNTAINS NATIONAL PARK, NORTH CAROLINA & TENNESSEE

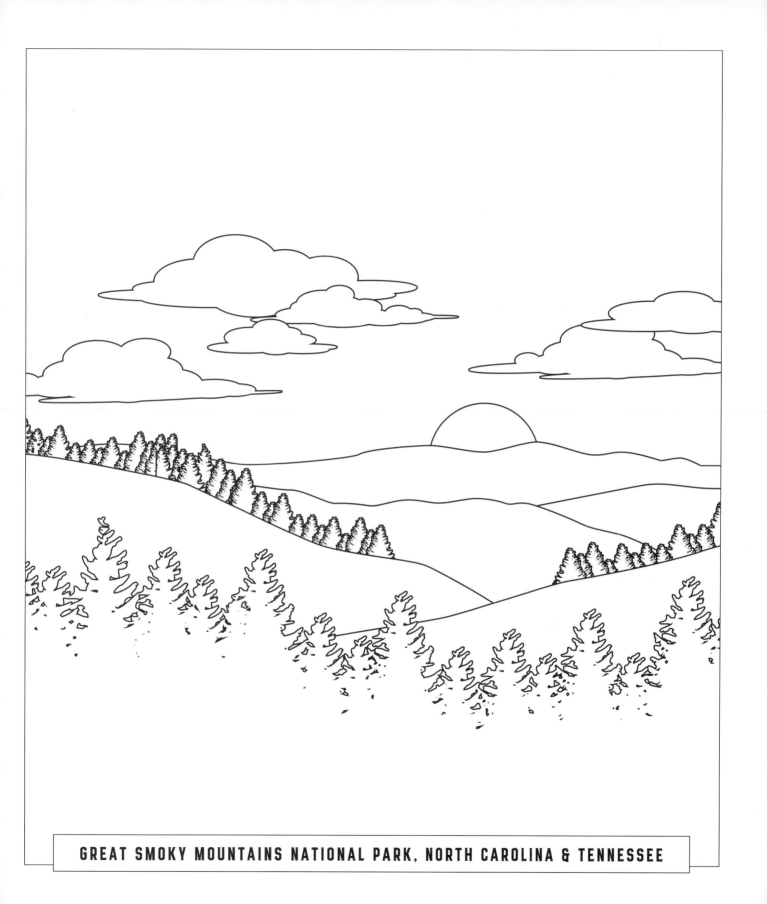

GREAT SMOKY MOUNTAINS NATIONAL PARK, NORTH CAROLINA & TENNESSEE

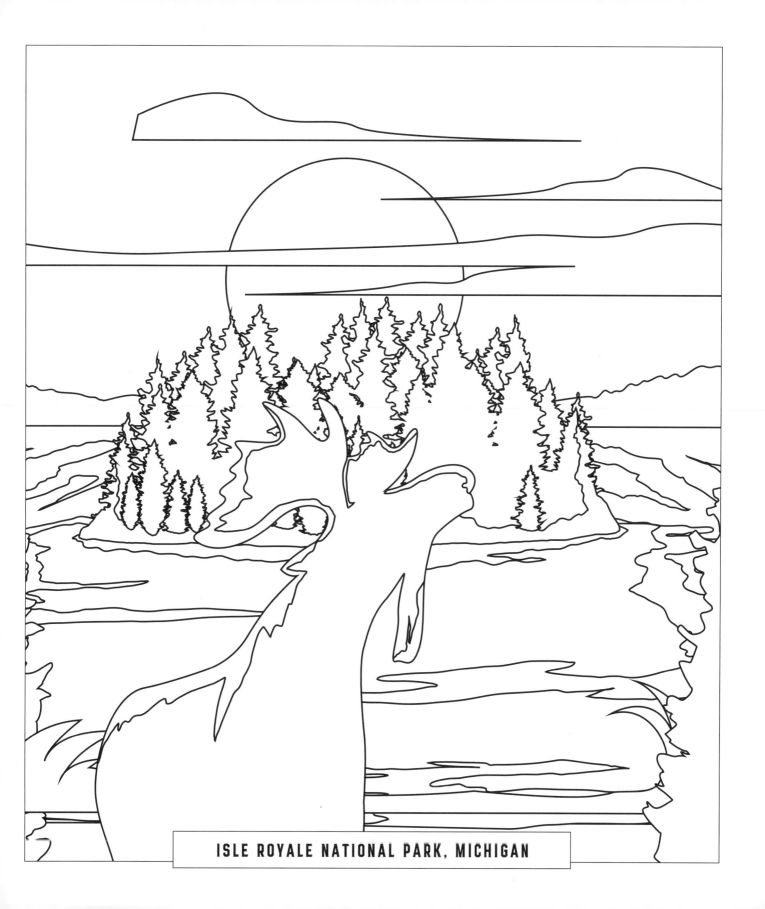

ISLE ROYALE NATIONAL PARK, MICHIGAN

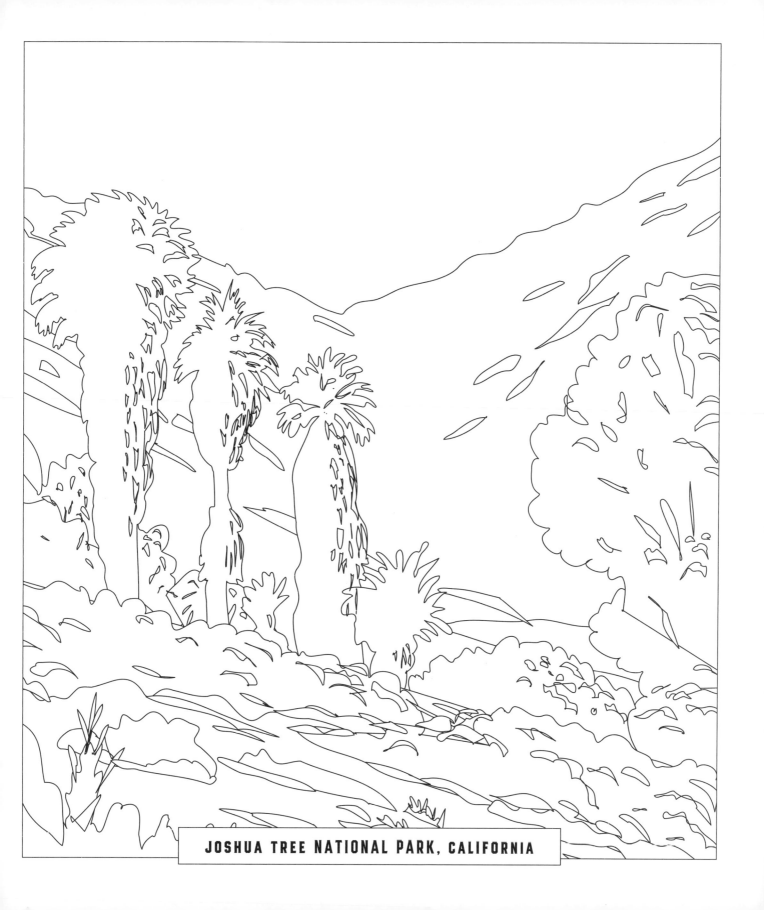

JOSHUA TREE NATIONAL PARK, CALIFORNIA

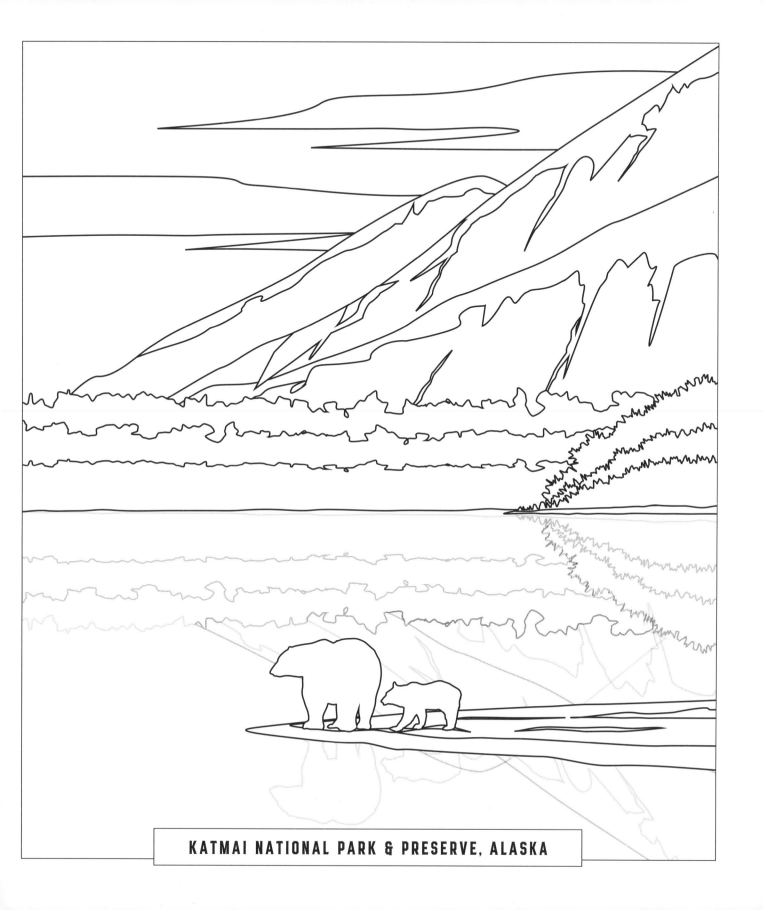

KATMAI NATIONAL PARK & PRESERVE, ALASKA

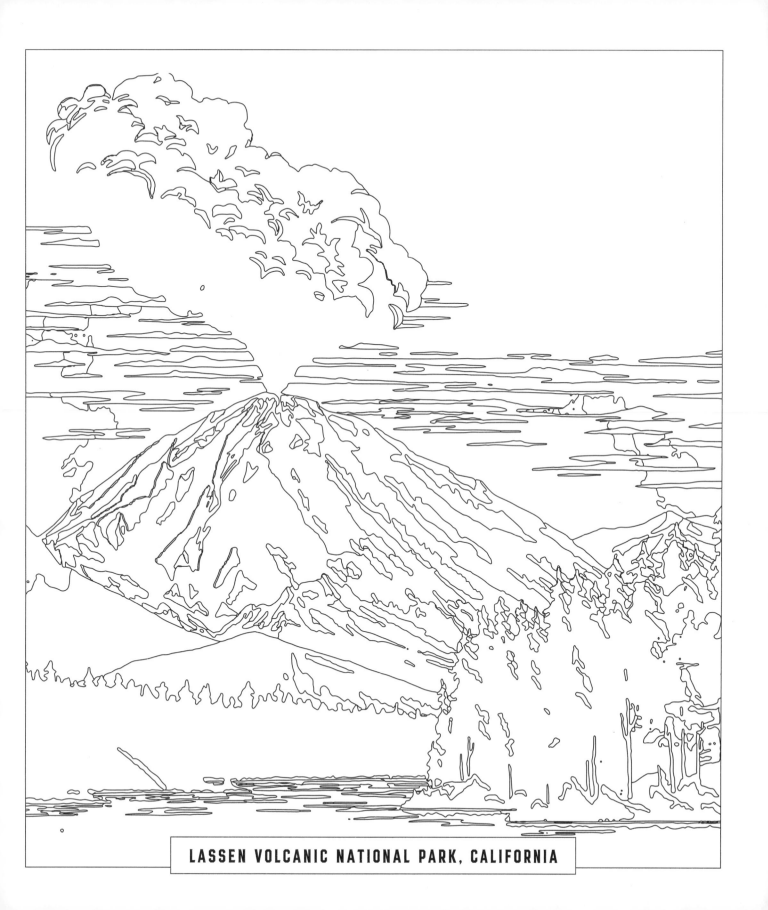

LASSEN VOLCANIC NATIONAL PARK, CALIFORNIA

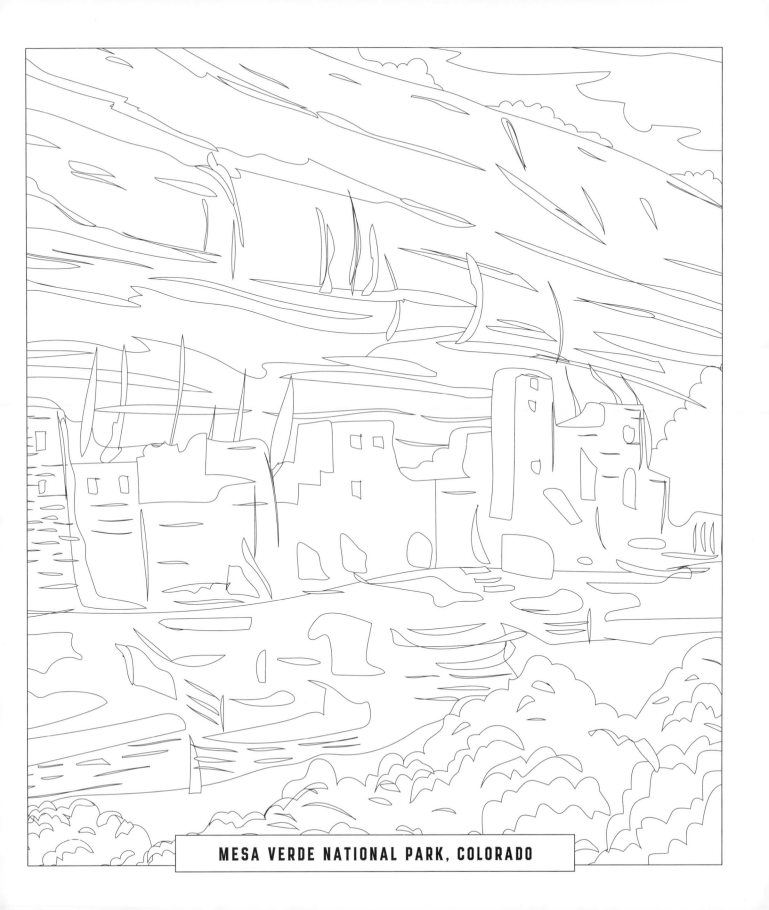

MESA VERDE NATIONAL PARK, COLORADO

MOUNT RAINIER NATIONAL PARK, WASHINGTON

MOUNT RAINIER NATIONAL PARK, WASHINGTON

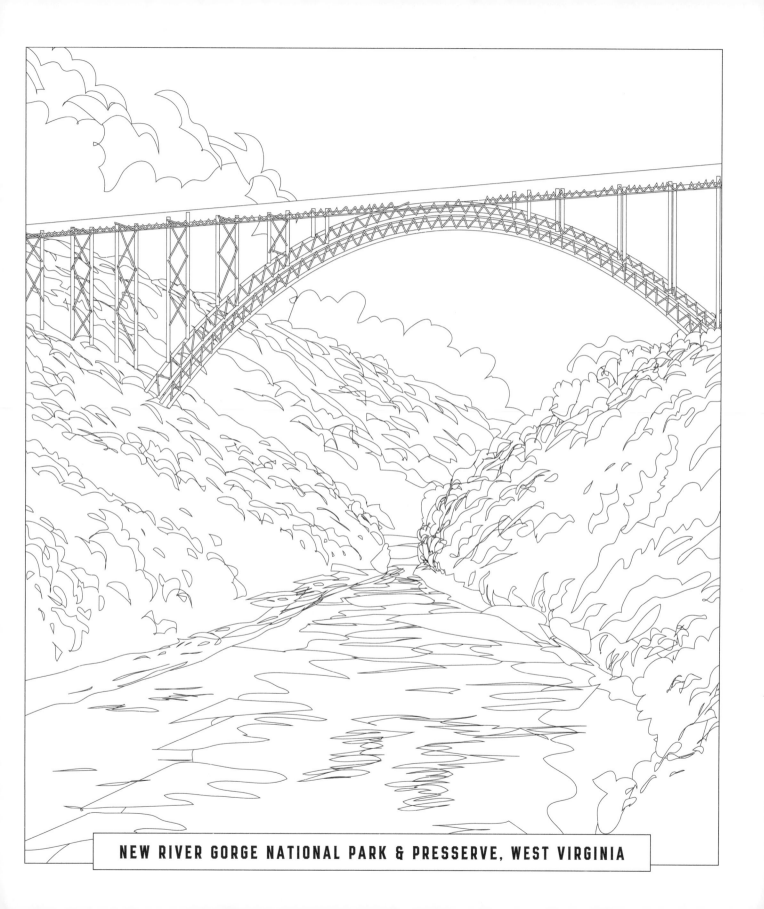

NEW RIVER GORGE NATIONAL PARK & PRESSERVE, WEST VIRGINIA

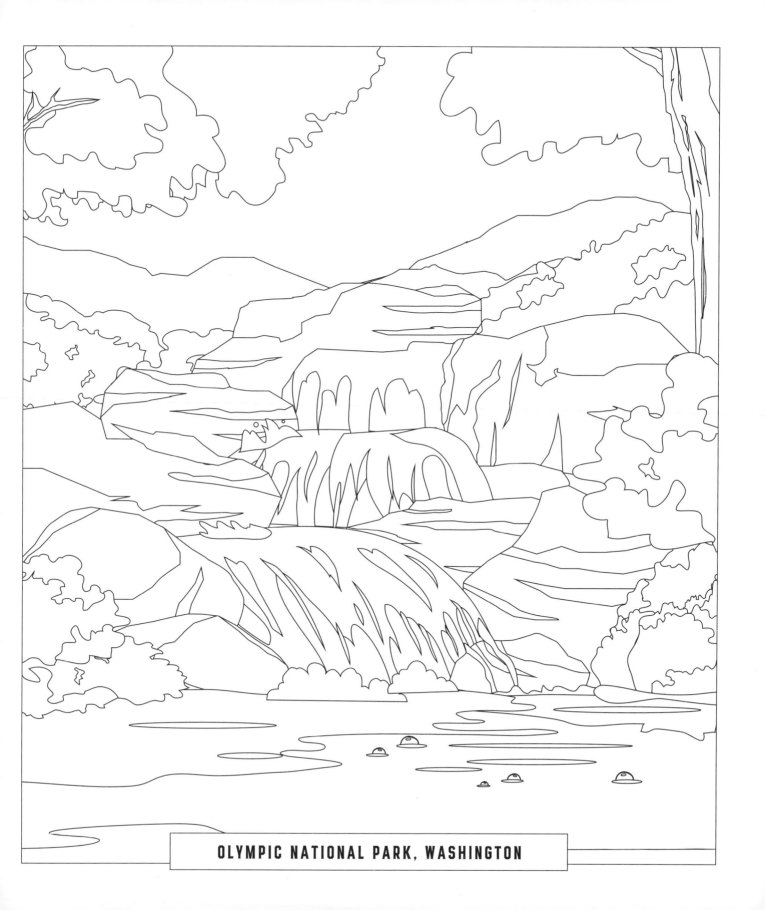

OLYMPIC NATIONAL PARK, WASHINGTON

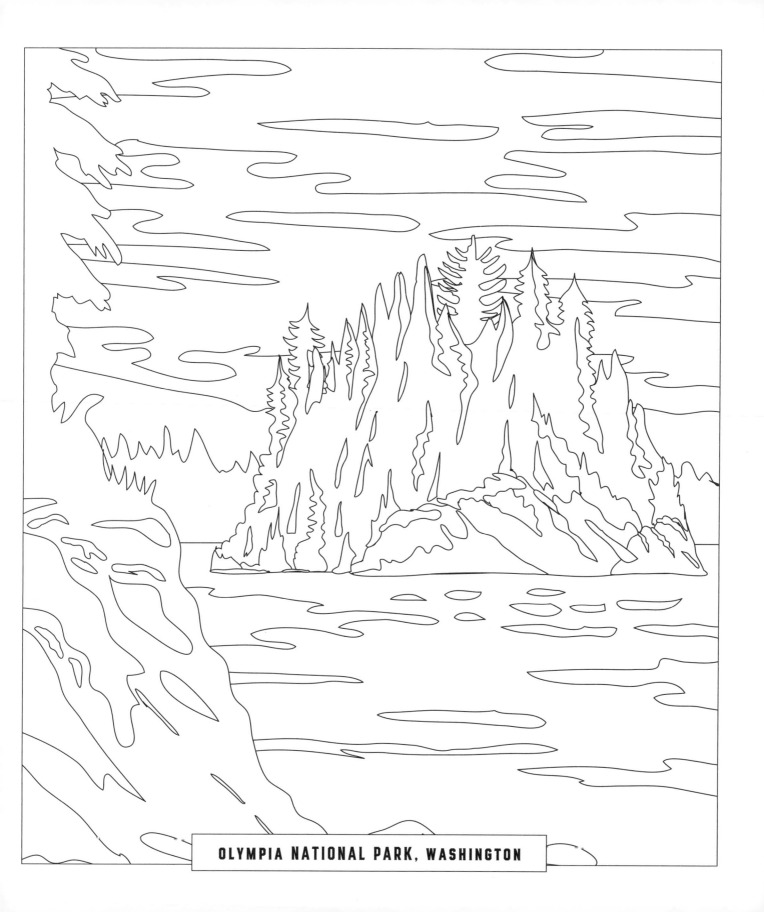

OLYMPIA NATIONAL PARK, WASHINGTON

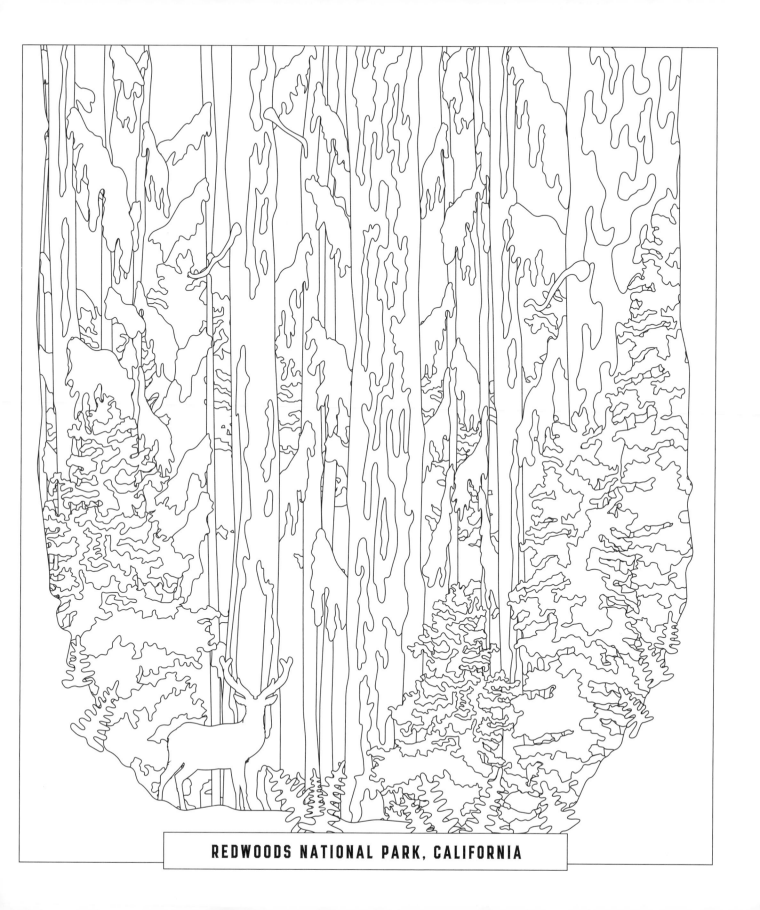

REDWOODS NATIONAL PARK, CALIFORNIA

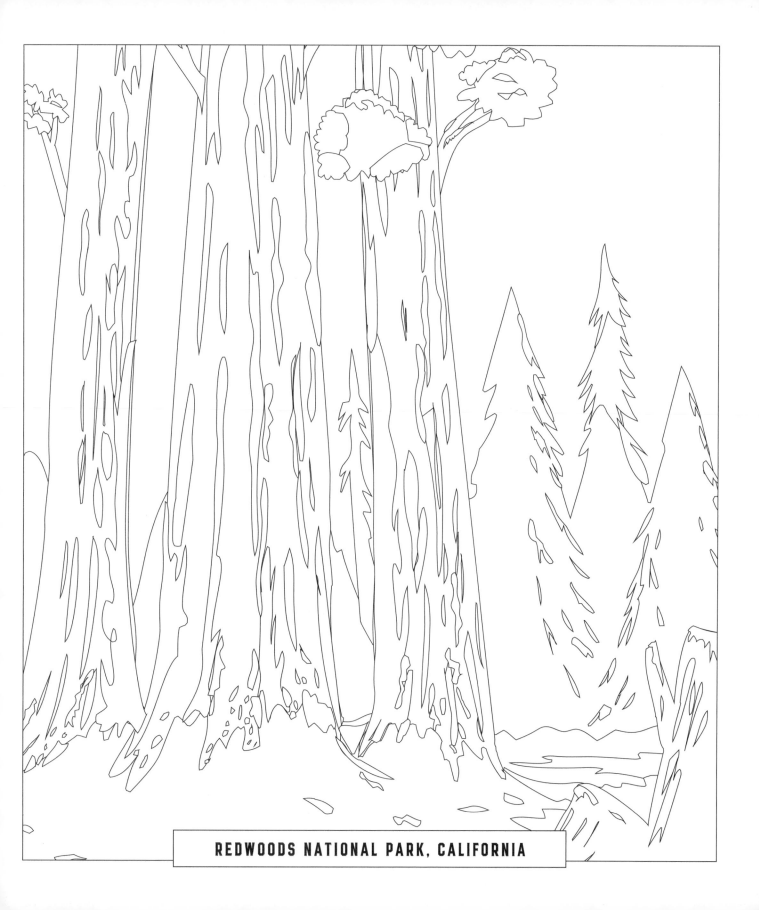

REDWOODS NATIONAL PARK, CALIFORNIA

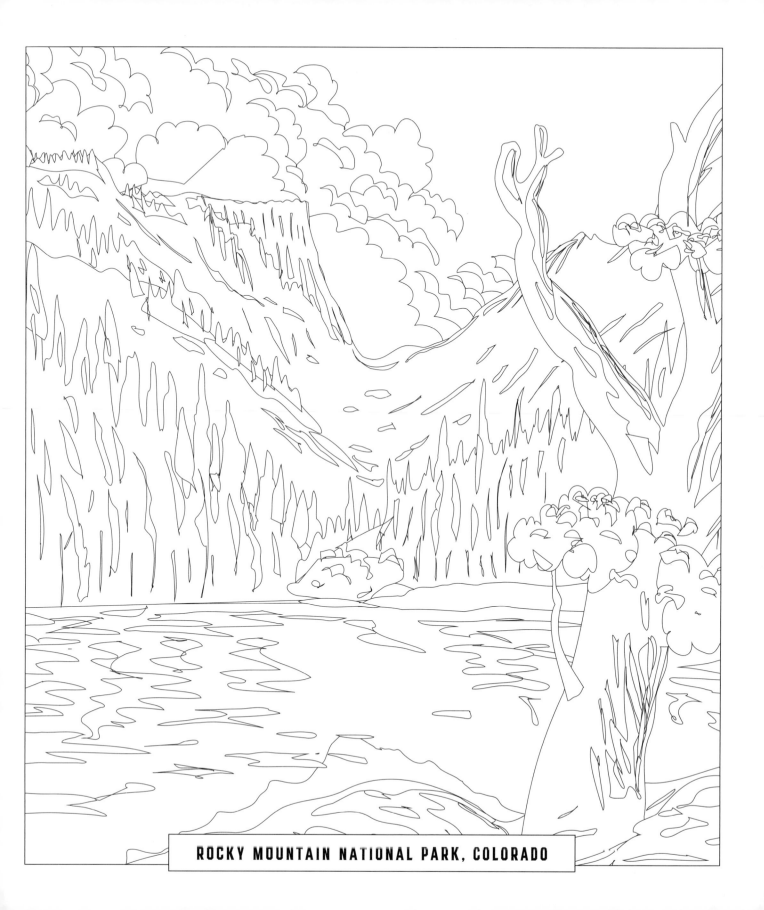

ROCKY MOUNTAIN NATIONAL PARK, COLORADO

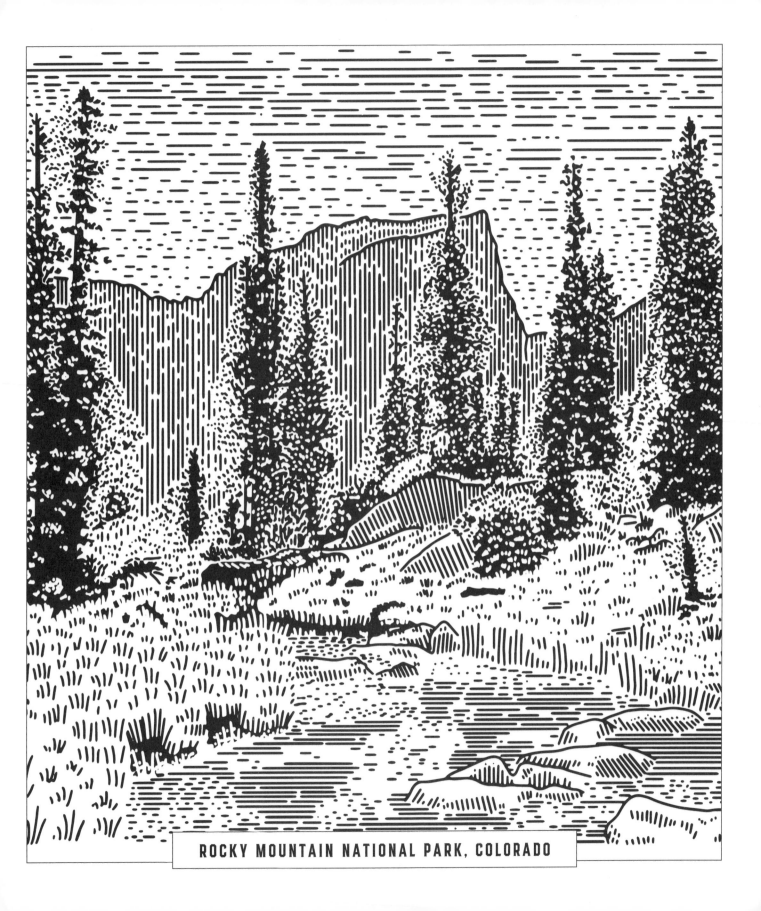

ROCKY MOUNTAIN NATIONAL PARK, COLORADO

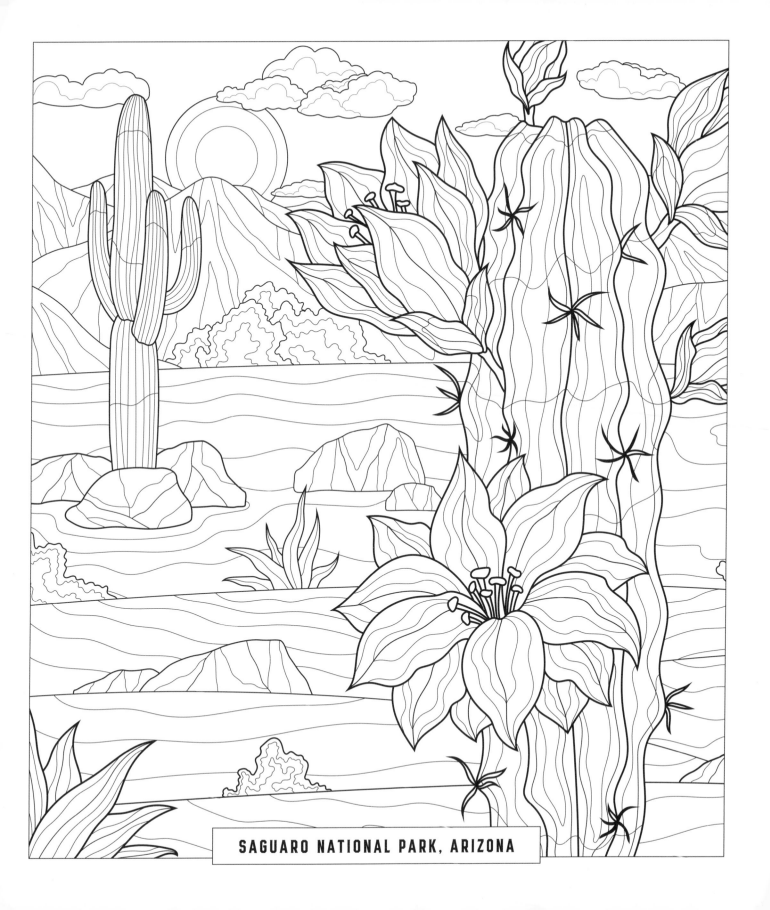

SAGUARO NATIONAL PARK, ARIZONA

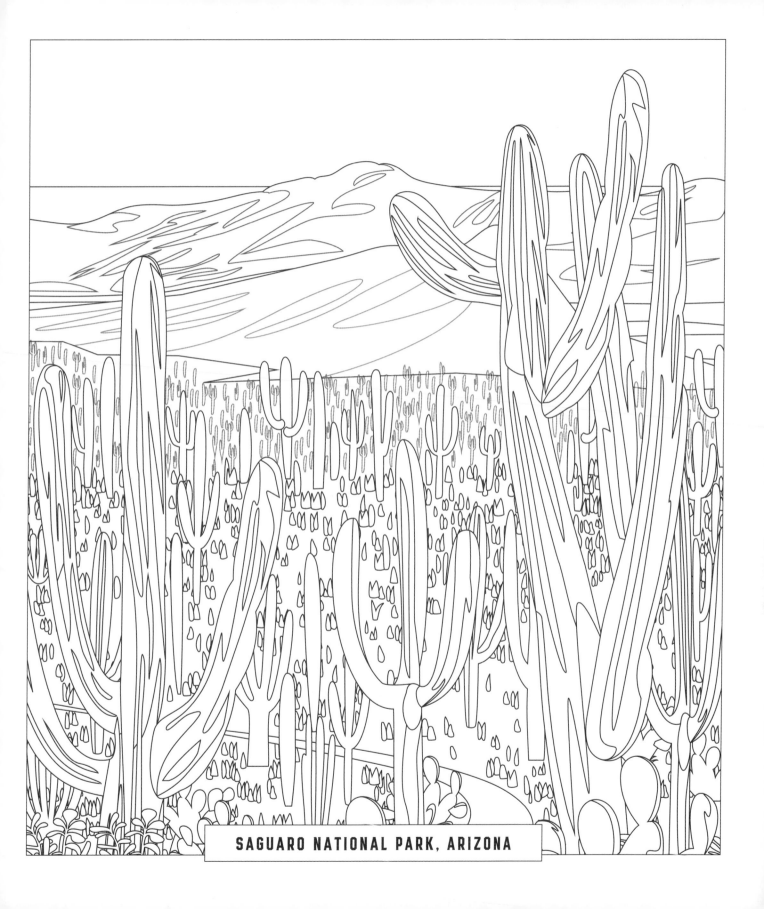

SAGUARO NATIONAL PARK, ARIZONA

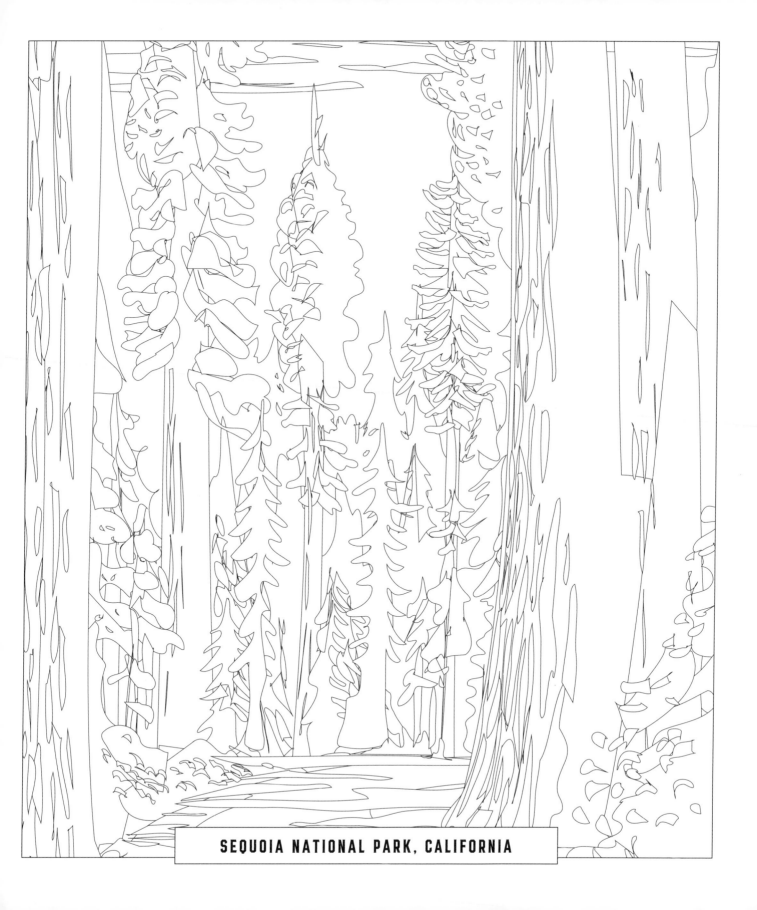

SEQUOIA NATIONAL PARK, CALIFORNIA

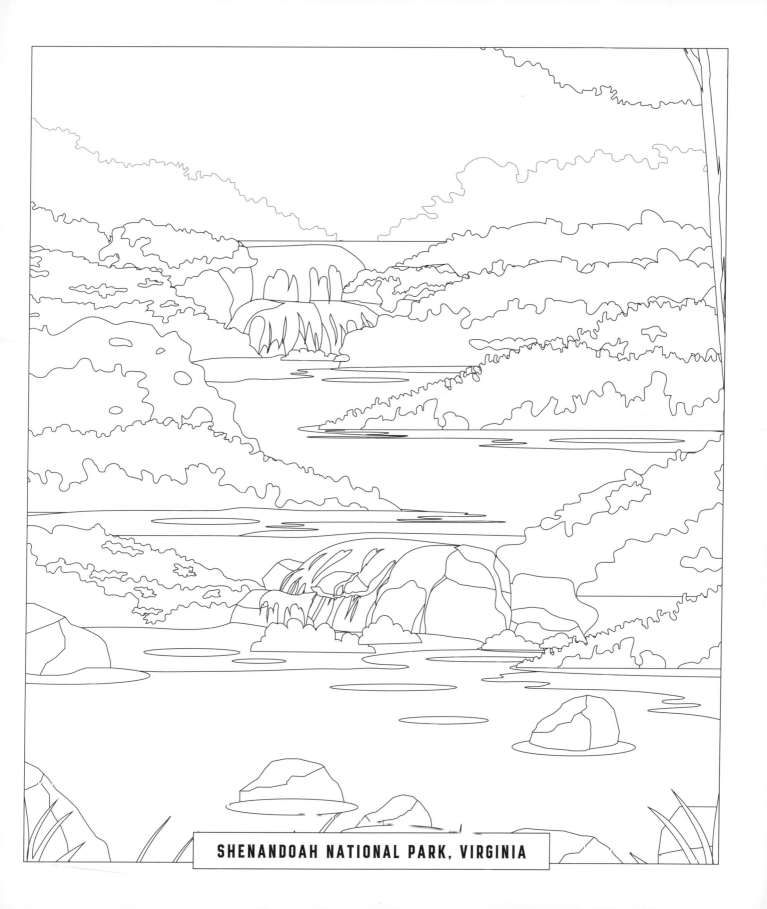

SHENANDOAH NATIONAL PARK, VIRGINIA

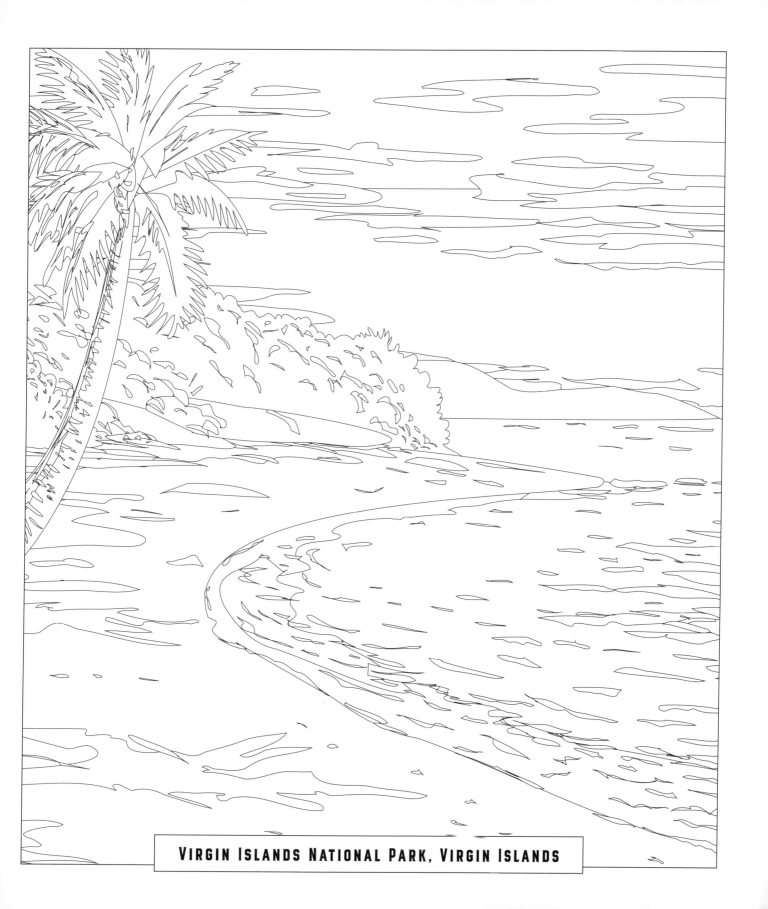

VIRGIN ISLANDS NATIONAL PARK, VIRGIN ISLANDS

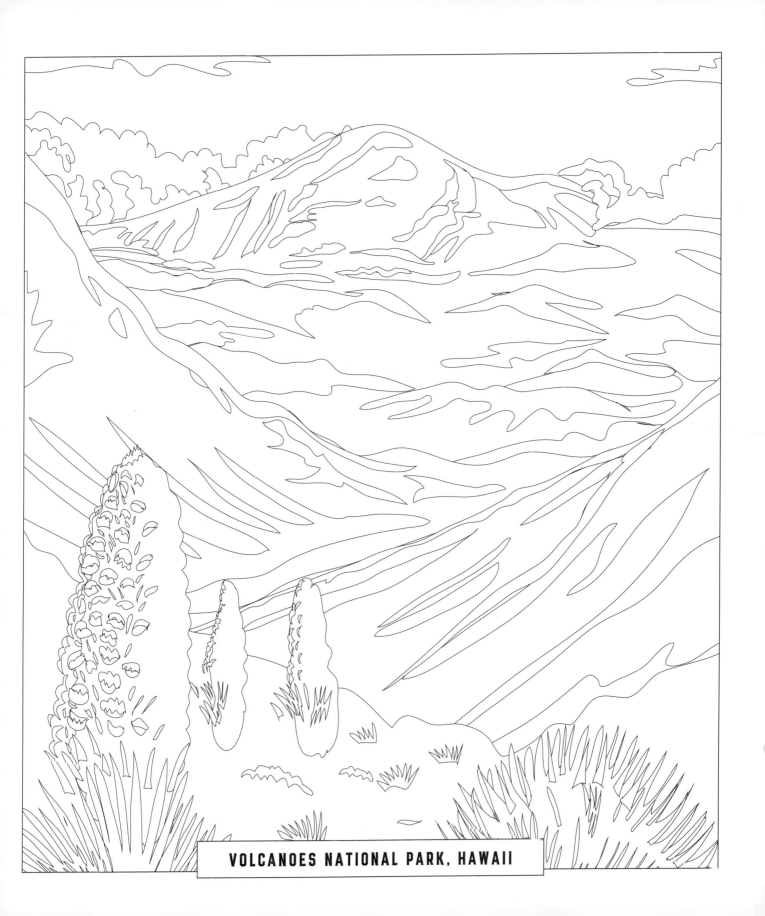

VOLCANOES NATIONAL PARK, HAWAII

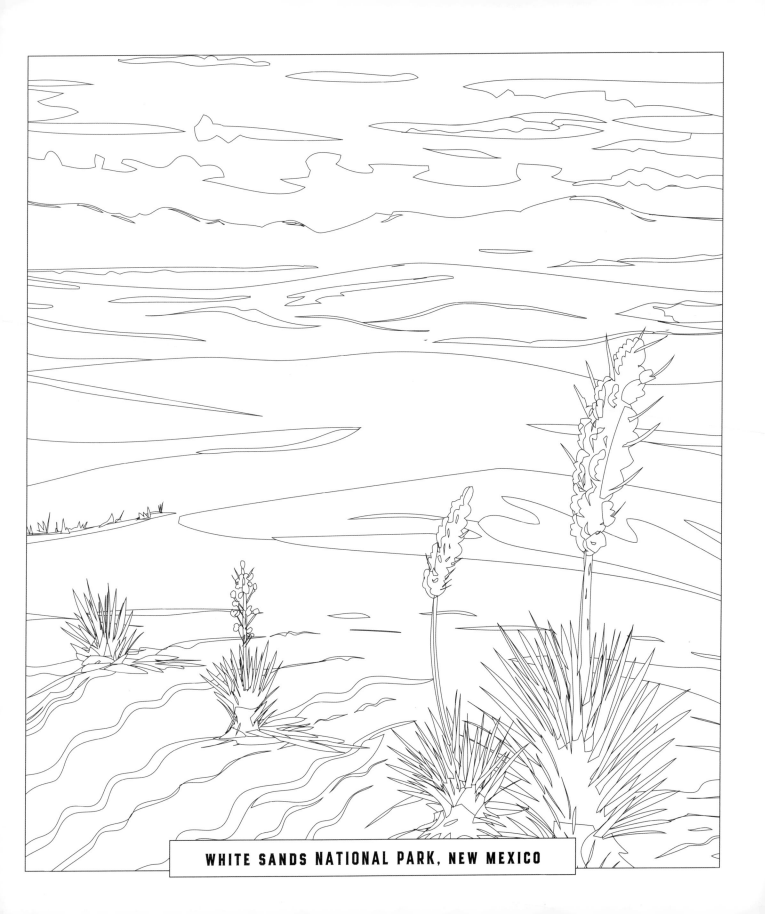

WHITE SANDS NATIONAL PARK, NEW MEXICO

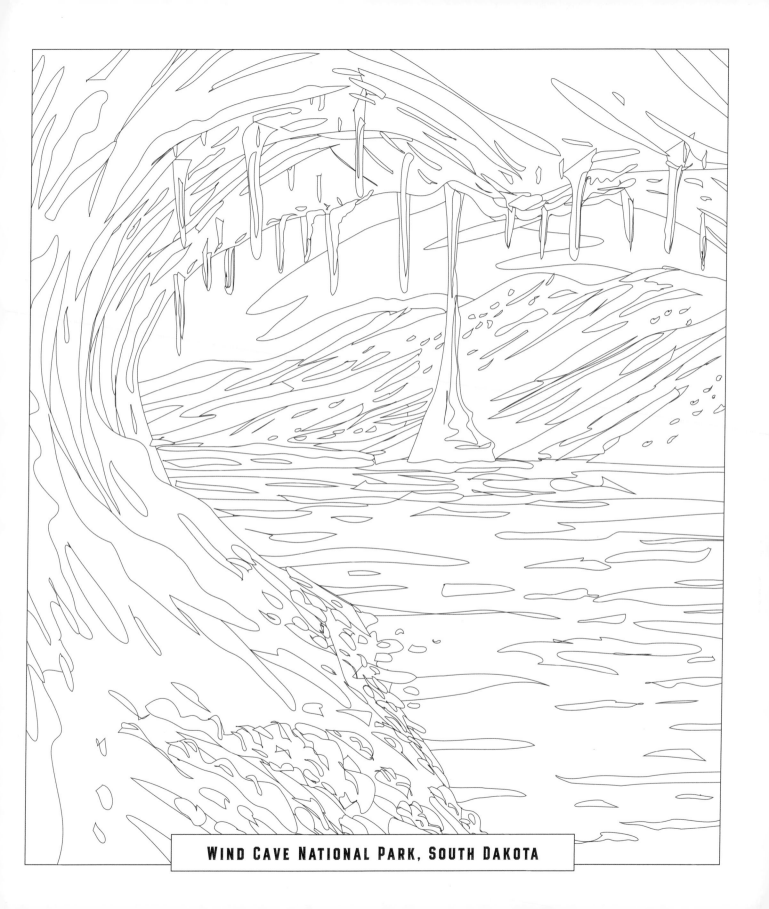

WIND CAVE NATIONAL PARK, SOUTH DAKOTA

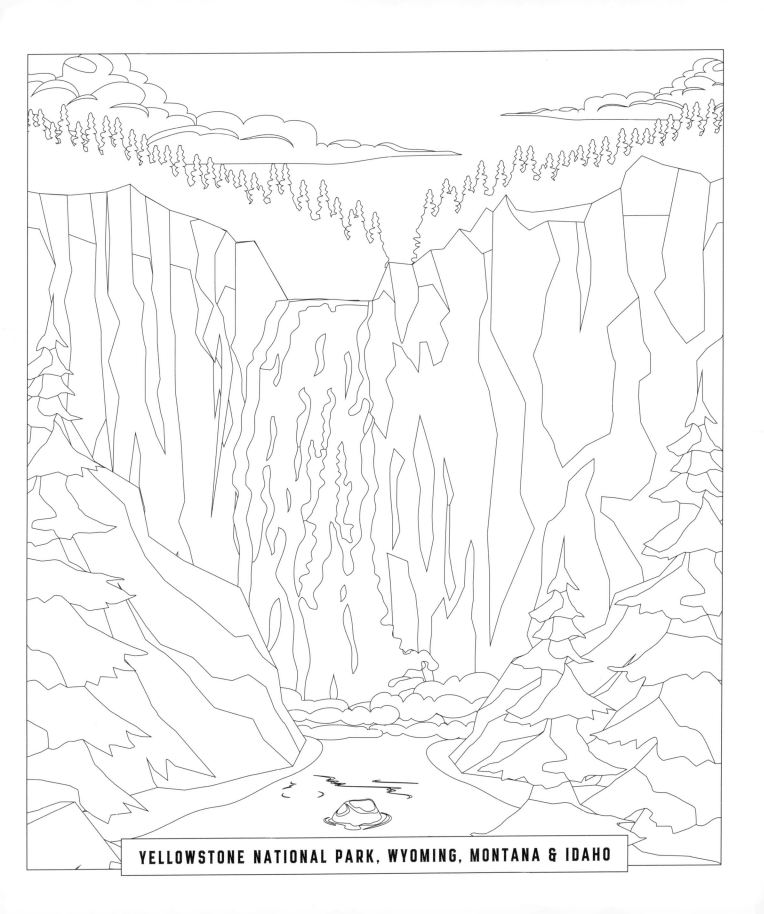

YELLOWSTONE NATIONAL PARK, WYOMING, MONTANA & IDAHO

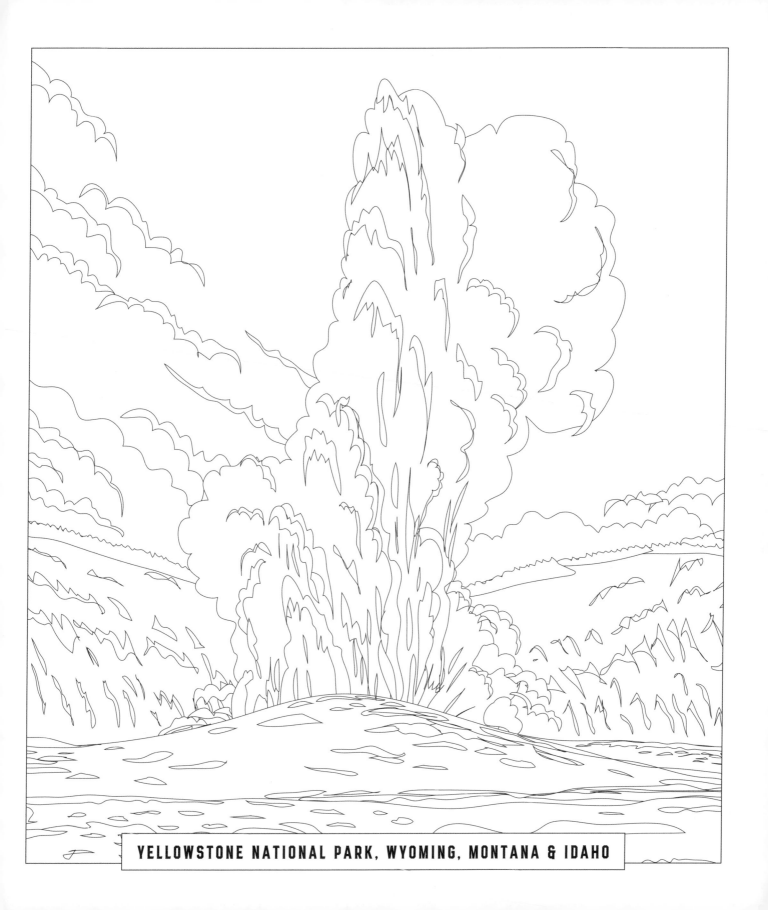

YELLOWSTONE NATIONAL PARK, WYOMING, MONTANA & IDAHO

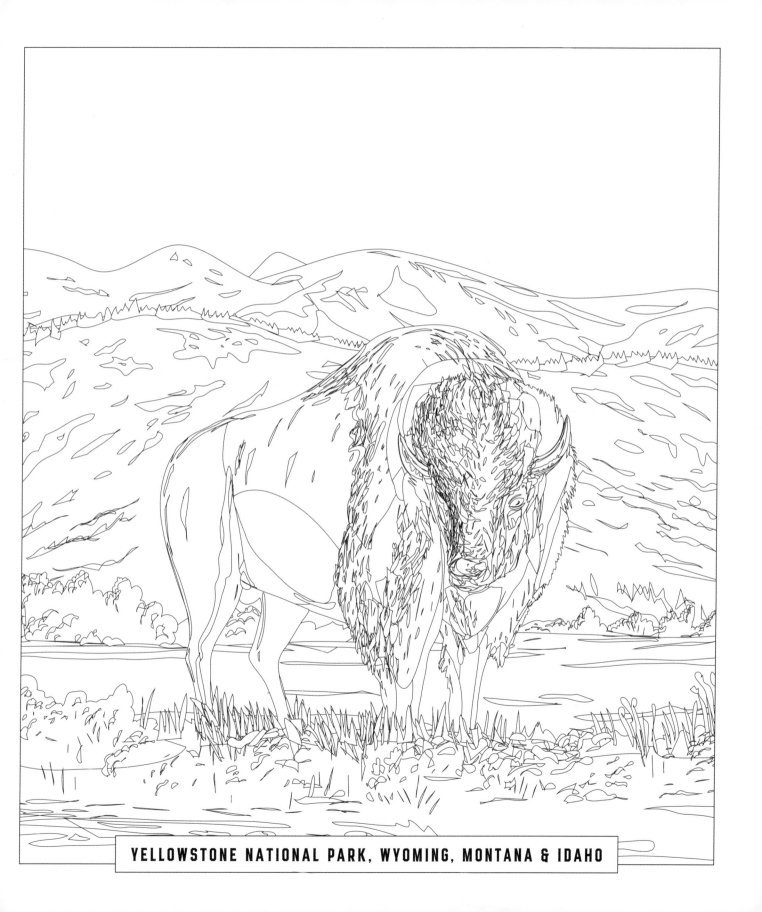

YELLOWSTONE NATIONAL PARK, WYOMING, MONTANA & IDAHO

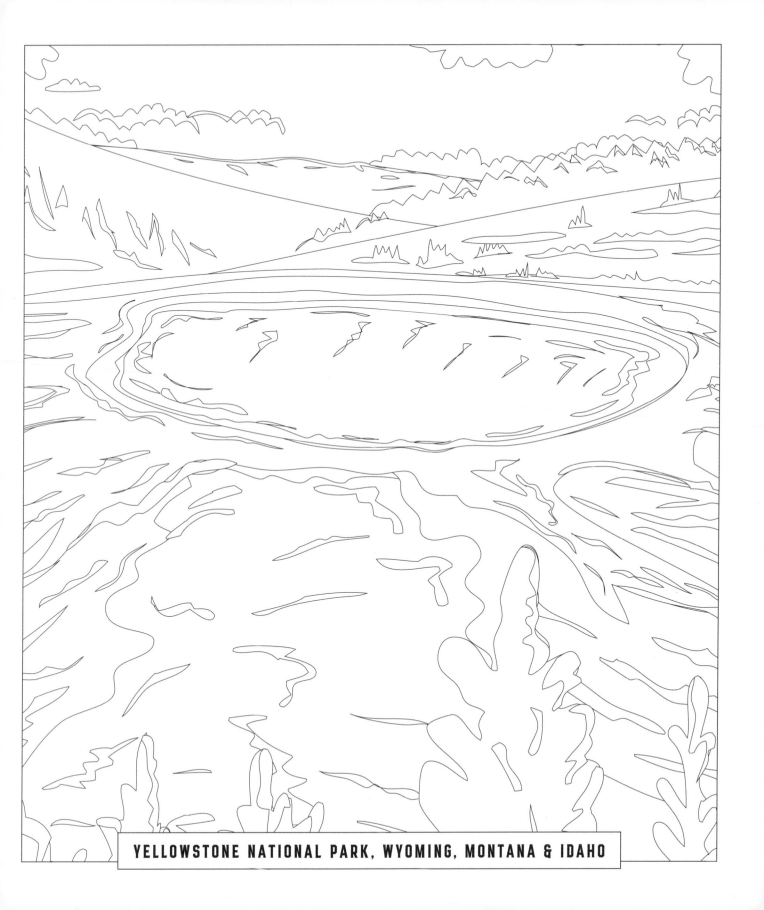

YELLOWSTONE NATIONAL PARK, WYOMING, MONTANA & IDAHO

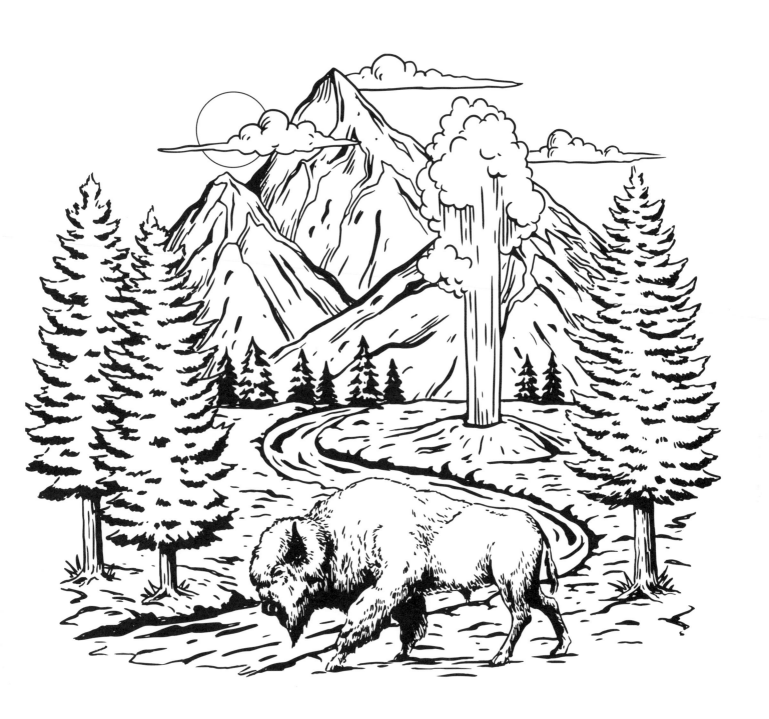

YELLOWSTONE NATIONAL PARK, WYOMING, MONTANA & IDAHO

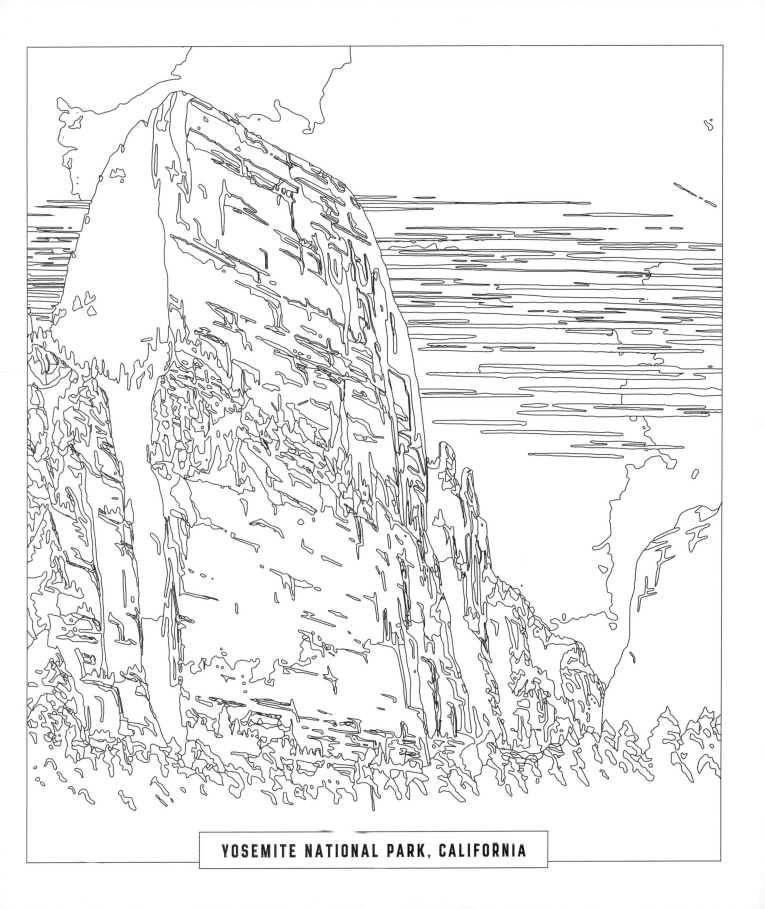

YOSEMITE NATIONAL PARK, CALIFORNIA

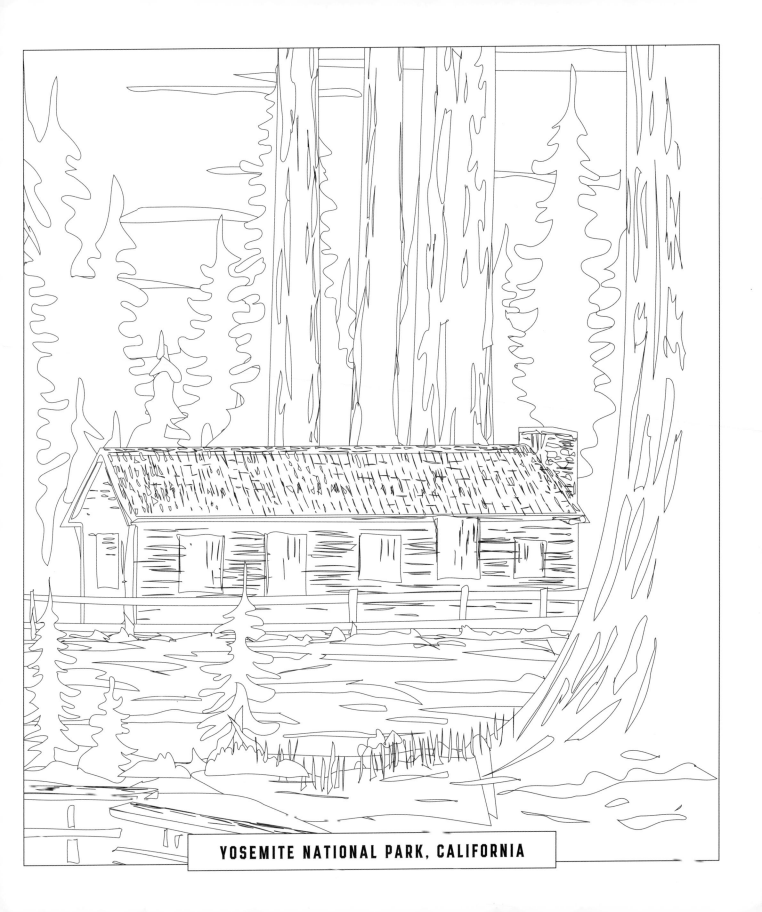

YOSEMITE NATIONAL PARK, CALIFORNIA

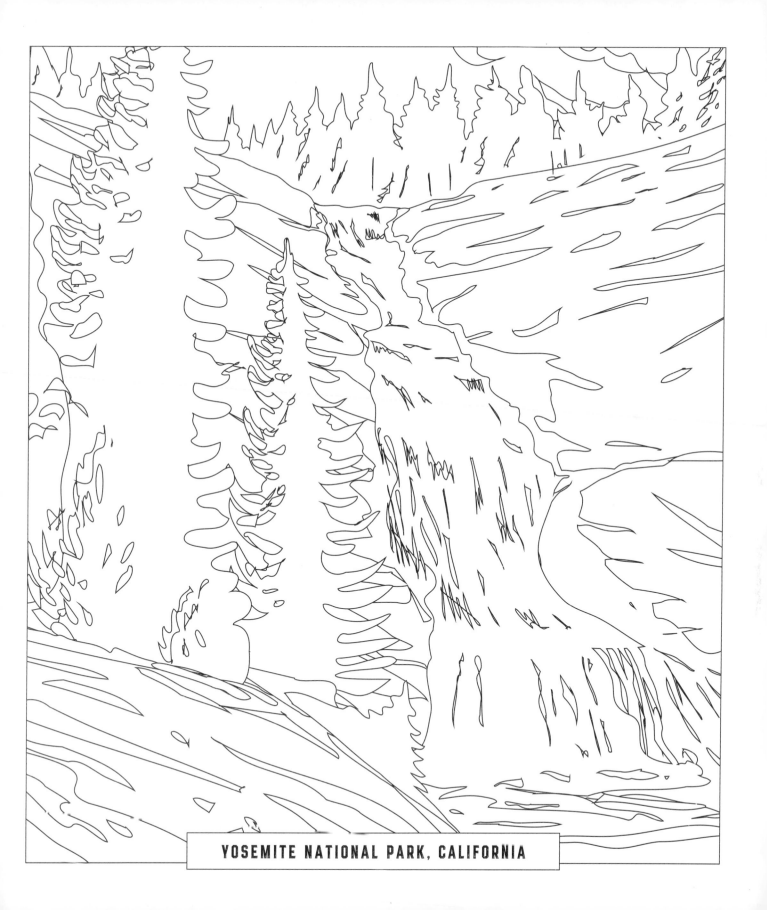

YOSEMITE NATIONAL PARK, CALIFORNIA

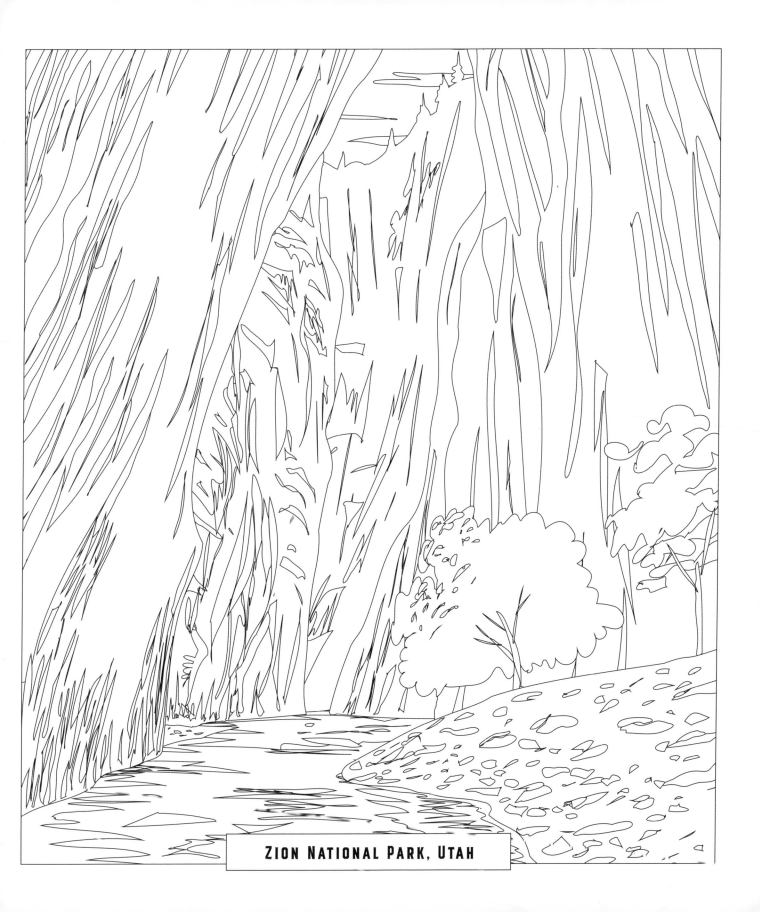

ZION NATIONAL PARK, UTAH

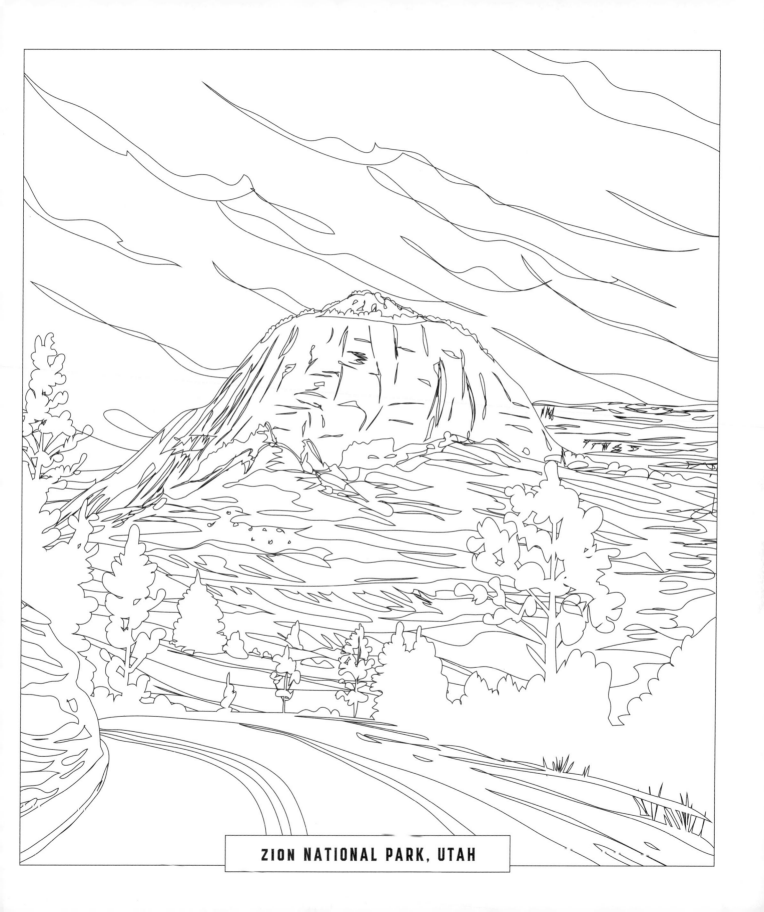

ZION NATIONAL PARK, UTAH

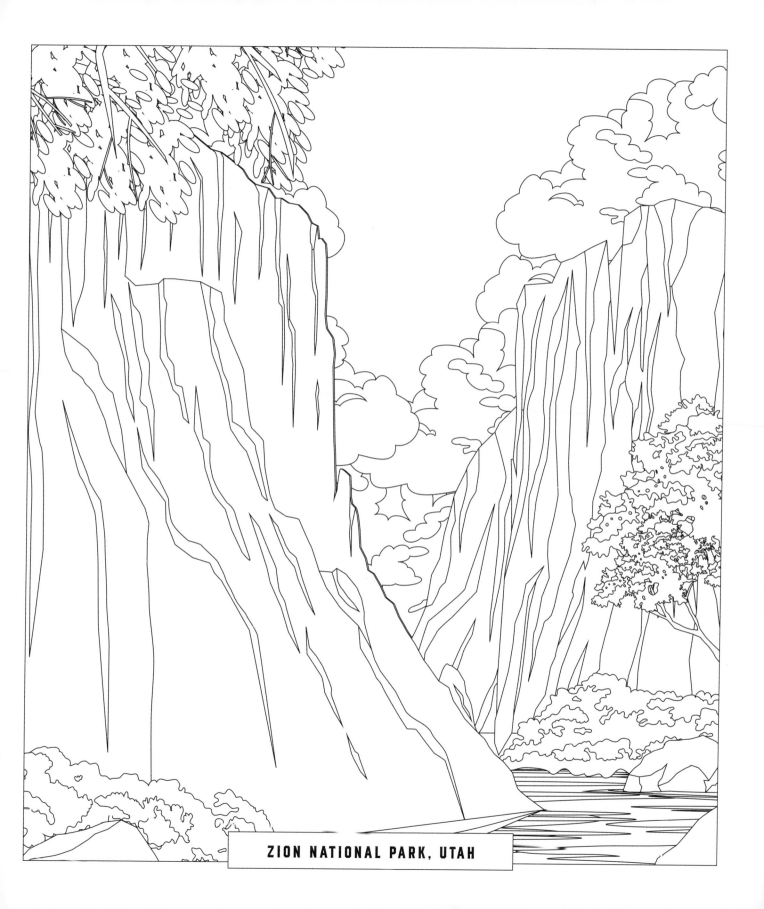

ZION NATIONAL PARK, UTAH

Brimming with creative inspiration, how-to projects, and useful information to enrich your everyday life, quarto.com is a favorite destination for those pursuing their interests and passions.

This edition published in 2023 by Chartwell Books,
an imprint of The Quarto Group
142 West 36th Street, 4th Floor
New York, NY 10018 USA
T (212) 779-4972 F (212) 779-6058
www.Quarto.com

10 9 8 7 6 5 4 3 2 1

Chartwell titles are also available at discount for retail, wholesale, promotional, and bulk purchase. For details, contact the Special Sales Manager by email at specialsales@quarto.com or by mail at The Quarto Group, Attn: Special Sales Manager, 100 Cummings Center Suite 265D, Beverly, MA 01915, USA.

ISBN: 978-0-7858-4268-2

Publisher: Wendy Friedman
Senior Managing Editor: Meredith Mennitt
Senior Design & Product Development Manager: Michael Caputo
Designers: Sue Boylan, Alana Ward
Editor: Joanne O'Sullivan
Image credits: Shutterstock

Printed in China

CHAPTER 1
BREAKFAST

CARROT CAKE PANCAKES

Makes 6 pancakes

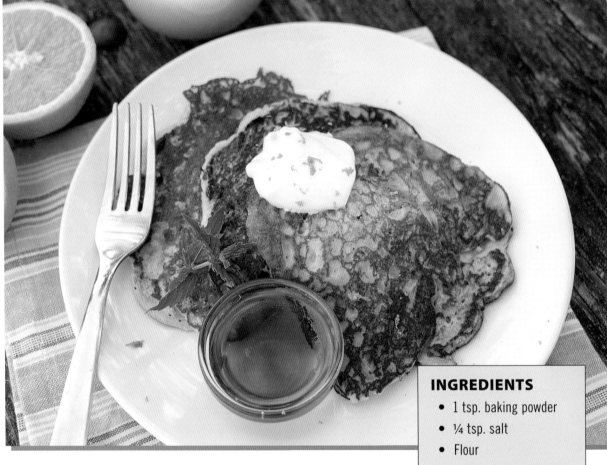

Put the baking powder and salt in a ¾-cup measuring cup; fill with flour and dump into a bowl. Add the allspice, sugar, eggs, carrots, milk, and ½ cup yogurt. Grab a spoon and stir to combine, then stir in the raisins.

Heat a griddle or skillet on a rack over a medium cooking fire (not too hot—you want to cook the pancakes all the way through without burning) and add a little oil. Use a ½-cup measuring cup to pour batter into the hot oil and to spread the batter out slightly. Flip the pancakes once the bottoms are golden brown, then cook until the other sides are golden. Serve them with honey or syrup and a dollop of yogurt.

INGREDIENTS

- 1 tsp. baking powder
- ¼ tsp. salt
- Flour
- ½ tsp. ground allspice
- 2½ T. sugar
- 2 eggs
- ¾ C. carrots, shredded
- ½ C. milk
- ½ C. plain yogurt, plus more for serving
- ⅓ C. golden raisins
- Vegetable oil
- Honey or maple syrup for serving

COWBOY CAMP COFFEE

Makes 1 pot

INGREDIENTS
- 9 C. water, divided
- 1¾ to 2 C. ground coffee

Fill large clean can or deep cooking pot with 8 cups water. Let warm on fire grate.

Add coffee to the water. Cook at rolling boil for 2 to 3 minutes.

Remove from heat and allow to sit 2 to 3 minutes.

Gently pour in 1 cup cold water. This makes grounds settle to the bottom.

Pour yourself a cup and enjoy.

ICED COFFEE

Makes 1 quart

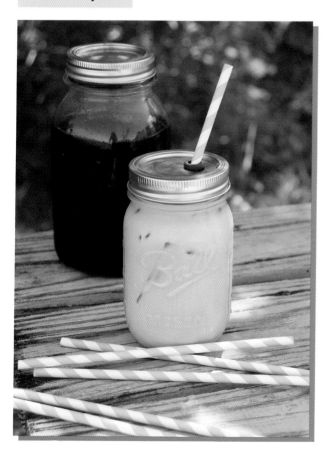

INGREDIENTS
- ½ C. ground coffee
- Water
- Half-and-half
- Sweetened condensed milk

At home, place ground coffee in a 1 quart mason jar and fill with water. Cover and let sit at room temperature for 8 hours. Pour liquid through a coffee filter-lined strainer; repeat with a fresh filter. Discard solids and pour liquid into a clean quart jar. Add water to fill jar. Cover and chill.

At camp, fill a 1 pint mason jar with ice and fill ⅔ full with coffee concentrate you mixed at home. Add a generous splash of half-and-half and 2 to 3 tablespoons sweetened condensed milk; stir well.

Keep remaining concentrate chilled until needed.

FLAKY WALNUT PASTRIES

Makes 1 pastry

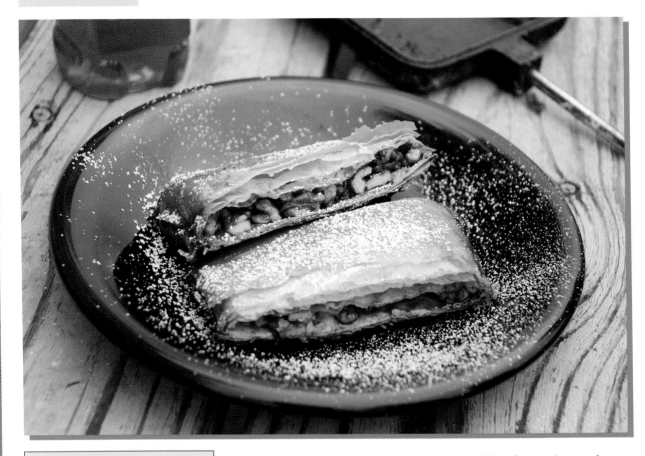

INGREDIENTS

- Phyllo dough
- Chopped walnuts
- Cinnamon
- Brown sugar
- Butter
- Honey

Grease a pie iron. Stack five or six layers of dough, coating each with cooking spray. Cut stack into pieces a little bigger than your iron.

Set one of these little stacks in the iron.

Pile on walnuts; add cinnamon, brown sugar, and some butter. Drizzle on a good amount of honey. Add another dough stack, close iron, and trim.

Hold over warm coals to toast slowly.

Serve with extra honey and garnish as you see fit.

CHEESY BACON BUNS

Makes 8 servings

INGREDIENTS

- Egg
- Milk
- One 8-ct. pkg. jumbo refrigerated flaky biscuits
- Bacon, cooked and chopped
- Cheddar cheese, shredded
- Green onion, chopped

Beat egg with a bit of milk. Cut each biscuit into eight pieces; add to egg mixture. Stir in bacon, Cheddar cheese, and green onion. Fill one side of a greased pie iron with mixture, close iron, and cook over warm coals until done, turning only once near the end of cooking.

BACON AND POTATO PANCAKES

Makes 6 pancakes

INGREDIENTS

- 1½ lbs. yellow potatoes, peeled and diced
- 4 bacon strips
- One 13.5-oz. can coconut milk, divided
- 2 eggs
- 2 tsp. chives, chopped
- ¾ tsp. salt

Cook potatoes in boiling water in a big non-stick skillet until soft; drain and dump into a bowl. Dry the skillet and cook bacon strips until crisp; chop and set aside. Add half of coconut milk to the potatoes; mash until combined. Beat in eggs until incorporated. Beat in more coconut milk, until the consistency of pancake batter. Stir in chives, bacon, and salt.

Wipe out most of the grease from the skillet; heat on on a grate over a medium heat cooking fire. For each pancake, slowly pour ⅓ cup batter into the skillet and cook to brown both sides, turning once. Serve with maple syrup, sour cream, bacon, and/or chives.

FLUFFY FLAPJACKS

Makes 12 flapjacks

INGREDIENTS

- 5 eggs
- 2 C. pancake mix
- 2 T. sugar
- ½ tsp. cinnamon
- 2 T. melted butter
- ½ C. ginger ale
- Butter and maple syrup for serving

In a bowl, whisk the eggs until well beaten. Add the pancake mix, sugar, and cinnamon. Pour in the butter and ginger ale. Stir until just combined (the mixture will be lumpy).

Heat a griddle or skillet over your cooking fire and spritz with cooking spray. Pour the batter onto the hot pan using about ⅓ cup for each pancake. Cook until golden brown on both sides, flipping once.

Serve with butter and maple syrup.

BERRY-LICIOUS FRENCH TOAST

Makes 6 to 8 servings

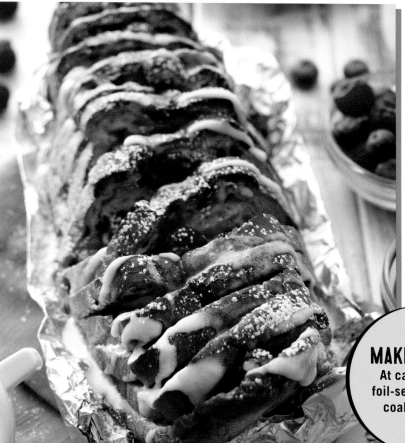

INGREDIENTS

- 1 loaf (1 lb.) sliced cinnamon-raisin bread
- 6 eggs
- 1 tsp. vanilla
- ⅓ C. milk
- ¾ C. heavy cream, divided
- 2 T. pure maple syrup, plus more for serving
- 1 to 1½ C. fresh blueberries and/or raspberries
- 1 C. powdered sugar

MAKE AHEAD!
At camp, place foil-sealed loaf in coals to heat.

Heat oven to 375°F. Lay two big sheets of heavy-duty foil on top of each other on a rimmed baking sheet and spritz with cooking spray. Set the loaf of bread in the center of the foil; fold the edges up around the bottom half of the loaf to hold the bread in place and keep the egg mixture contained. Fan out the bread slices slightly.

In a bowl, beat the eggs. Whisk in the vanilla, milk, ½ cup of the cream, and 2 tablespoons of the maple syrup. Pour the mixture slowly over the top of the bread, making sure to soak both sides of each slice. Scatter the berries over the top, pushing some between the slices. Cover the bread with another big sheet of foil; crimp the edges to seal the bread inside. Bake for 30 to 45 minutes until the eggs are set, removing the top foil during the last 10 minutes if necessary to prevent overbrowning.

Mix the powdered sugar with enough of the remaining cream to make a drizzling consistency. Open the foil and drizzle the glaze over the bread. Serve with maple syrup.

OVERNIGHT APPLE PIE OATMEAL

Makes 4 servings

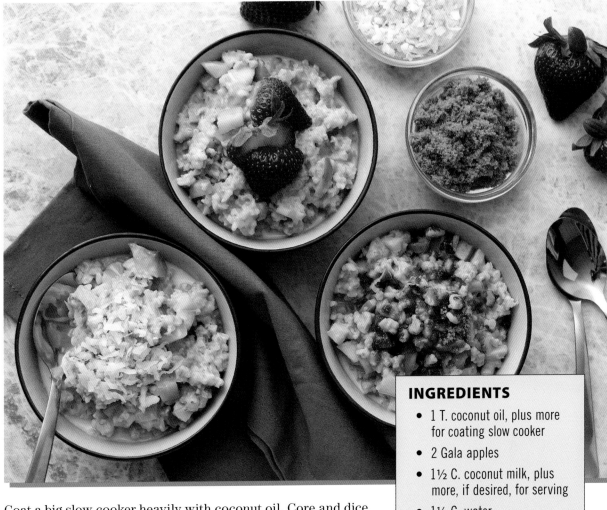

Coat a big slow cooker heavily with coconut oil. Core and dice apples and toss them into the cooker. Add coconut milk, water, steel-cut oats, coconut oil, sea salt, and vanilla. Stir to blend.

Cook on low for 5 to 7 hours, until the apples and oats are tender. Top servings with brown sugar, cinnamon, half-and-half or coconut milk, honey, and/or maple syrup, and a sprinkling of chopped walnuts and/or flaked or toasted coconut.

MAKE AHEAD! Store in foil baking pan and wrap in heavy-duty foil. Chill or freeze. At camp, place in hot coals to heat. Serve.

INGREDIENTS

- 1 T. coconut oil, plus more for coating slow cooker
- 2 Gala apples
- 1½ C. coconut milk, plus more, if desired, for serving
- 1½ C. water
- 1 C. steel-cut oats
- ¼ to ½ tsp. sea salt
- 1 tsp. vanilla
- Brown sugar, cinnamon, half-and-half, honey, and/or maple syrup for serving
- Chopped walnuts for serving
- Flaked or toasted coconut for serving

ALMOND FRENCH TOAST

Makes 4 servings

At home, in a small saucepan over low heat, place slivered almonds. Toast almonds until lightly browned, about 5 to 10 minutes, tossing frequently. Set aside 1½ cups of the toasted slivered almonds.

In a large bowl, using a whisk, combine eggs, milk, flour, salt, baking powder, almond extract, and vanilla. Mix well and soak each slice of bread in milk mixture until saturated. Place soaked slices of bread in a shallow pan and chill in refrigerator at least 30 minutes. Meanwhile, in a large skillet over medium heat, heat vegetable oil and butter. Place toasted slivered almonds in a shallow dish. Press slices of bread, one at a time, in the toasted almonds, until coated. Seal in heavy-duty foil and freeze.

At camp, thaw and place on grate over campfire or in a skillet to cook until golden brown on each side. Remove French toast to a plate and dust with powdered sugar.

INGREDIENTS

- 1 C. slivered almonds
- 3 eggs
- 1 C. milk
- 3 T. flour
- ¼ tsp. salt
- ½ tsp. baking powder
- ½ tsp. almond extract
- 1 tsp. vanilla
- 8 slices thick-cut bread
- 3 T. vegetable oil
- 3 T. butter
- Powdered sugar for dusting

HONEY BRAN MUFFINS

Makes 12 jumbo muffins

INGREDIENTS

- 2 C. pineapple juice
- 2 C. golden raisins
- 2 C. flour
- 2 tsp. baking soda
- 1 tsp. salt
- 1 C. whole bran cereal
- 1 C. brown sugar
- ½ C. vegetable oil
- ½ C. honey
- Eggs, beaten

At home, in a small bowl, combine pineapple juice and golden raisins. Mix lightly and set aside. In a medium bowl, combine flour, baking soda, and salt. Mix well and stir in whole bran cereal and set aside. In a large bowl, combine brown sugar, vegetable oil, honey, and beaten eggs. Mix well and stir in bran cereal mixture. Stir until well combined and fold in pineapple juice and raisins. Mix well. The batter will be thin. Cover and chill batter in refrigerator overnight. Pack in cooler for camp.

At camp, lightly grease 12 jumbo muffin cups and stir the chilled batter. Fill each muffin cup ¾ full with batter. Bake over hot campfire on grate for 20 to 25 minutes or until a toothpick inserted in center of muffins comes out clean. Remove muffins from tin and let cool on a wire rack for 10 minutes.

STRAWBERRY FRENCHIES

Makes 4 servings

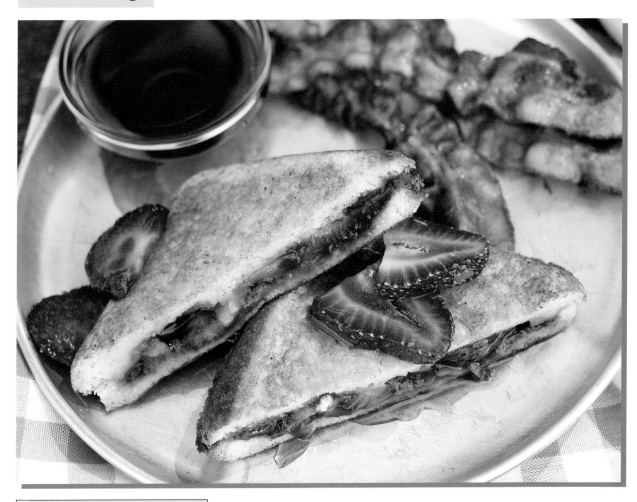

INGREDIENTS

- 3 eggs
- ¼ C. milk
- 1 tsp. cinnamon sugar
- Strawberry preserves
- 1 C. sliced strawberries

Whisk together eggs, milk, and cinnamon sugar. Dip one side of a bread slice into egg mixture and set in a greased pie iron, egg side down. Spread with strawberry preserves; arrange ¼ cup sliced strawberries over preserves. Dip another bread slice in egg and place it on top, egg side up. Close iron and cook in hot embers until toasted on both sides. Repeat to make three more. Serve with maple syrup.

BREAKFAST TARTS

Makes 4 servings

INGREDIENTS

- 9 to 11 oz. piecrust mix
- 8 slices bacon
- ½ C. Cheddar cheese, shredded
- 3 eggs
- 3 T. milk
- ¼ tsp. nutmeg
- ¼ tsp. pepper

Preheat oven to 425°F. Prepare pastry for a one-crust pie according to package directions. Divide pastry into four equal parts and roll each part into a 6" circle. Place each pastry circle in a large muffin cup or 6-ounce pastry cup, making pleats so the pastry covers the bottoms and sides of each cup. Poke the surface of each crust with a fork and bake in oven for 8 to 10 minutes, until crusts are lightly browned. Remove crusts from oven and reduce oven temperature to 350°F.

Meanwhile, in a medium skillet over medium-high heat, cook bacon until crisp. Remove bacon from skillet and drain on paper towels. Crumble two slices bacon into the bottom of each crust and sprinkle with 2 tablespoons of the shredded Cheddar cheese. In a small bowl, combine eggs, milk, nutmeg, and pepper; whisk together well. Pour a portion of the egg mixture over bacon and cheese in each crust. Return to oven for an additional 15 to 20 minutes until eggs are cooked.

MAKE AHEAD! Wrap in foil and reheat in coals or on a grate over the campfire.

BACON QUICHE TARTS

Makes 10 tarts

INGREDIENTS

- 12 slices bacon
- 8 oz. cream cheese, softened
- 2 T. milk
- 2 eggs
- ½ C. Swiss cheese, shredded
- 4 green onions, chopped
- One 10-oz. can refrigerated flaky biscuit dough

At home, preheat oven to 375°F. Lightly grease 10 muffin cups and set aside. In a large skillet over medium-high heat, cook bacon until browned. Remove bacon to paper towels to drain. In a medium bowl, combine the cream cheese, milk, and eggs. Using a hand mixer, beat ingredients together until smooth. Fold in shredded Swiss cheese and chopped green onions; set aside.

Separate biscuit dough into 10 biscuits. Press one biscuit into the bottom and up sides of each muffin cup. Crumble bacon and sprinkle half into the bottoms of the filled muffin cups, then spoon 2 tablespoons of the cream cheese mixture into each muffin cup. Bake in oven for 20 to 25 minutes until filling is set and crust is golden brown. Sprinkle the remaining crumbled bacon over each muffin cup and press lightly into the filling. Remove tarts from muffin cups and cool. Seal in heavy-duty foil.

At camp, place the foil-wrapped tarts in coals to warm. Serve.

CHAPTER 2

HAMBURGERS, HOT DOGS, AND ONE-DISH MAINS

SKILLET KIELBASA HASH

Makes 4 servings

INGREDIENTS

- Olive oil
- One 14-oz. pkg. turkey kielbasa, sliced into ¼" rounds
- 1 green bell pepper, diced
- ½ red bell pepper, diced
- 1 small sweet onion, diced
- Salt and black pepper
- 2 large Yukon gold potatoes
- Canola oil
- Salt and black pepper

At home, heat 1 tablespoon oil in a skillet; add the kielbasa and fry for 5 minutes, shaking the skillet a time or two to brown evenly. Transfer the kielbasa to a paper towel-lined plate to drain. Add the diced veggies to the skillet, season with salt and pepper, and cook until crisp-tender, stirring occasionally; transfer to the plate with the kielbasa and let everything cool. Put the kielbasa and veggies together in a covered container and chill.

At camp, dice the potatoes. In a heavy skillet over a fire or on a grill, heat 2 tablespoons oil over medium-high heat. Add the potatoes and season with salt and pepper. Fry until golden brown, stirring a few times to brown evenly. Add the chilled kielbasa and veggie mixture, toss to combine, and heat through.

DE-STRESSING CAMPFIRE MEALS

- Read through recipes before you go. Make sure you take any gadgets and tools you'll need.
- Make what you can at home. Mix dry ingredients, fillings, and spices; store in zippered plastic bags or containers with tight-fitting lids and label them.
- Buy shredded or sliced vegetables and cheese instead of doing all the work yourself.
- Remember that the timing for campfire cooking is approximate; adjust according to the heat of your fire, wind, and outdoor temperature.
- Improvise without worry. If you forget your skillet, try making the meal in a foil pack. Nobody has to know you didn't plan it that way.

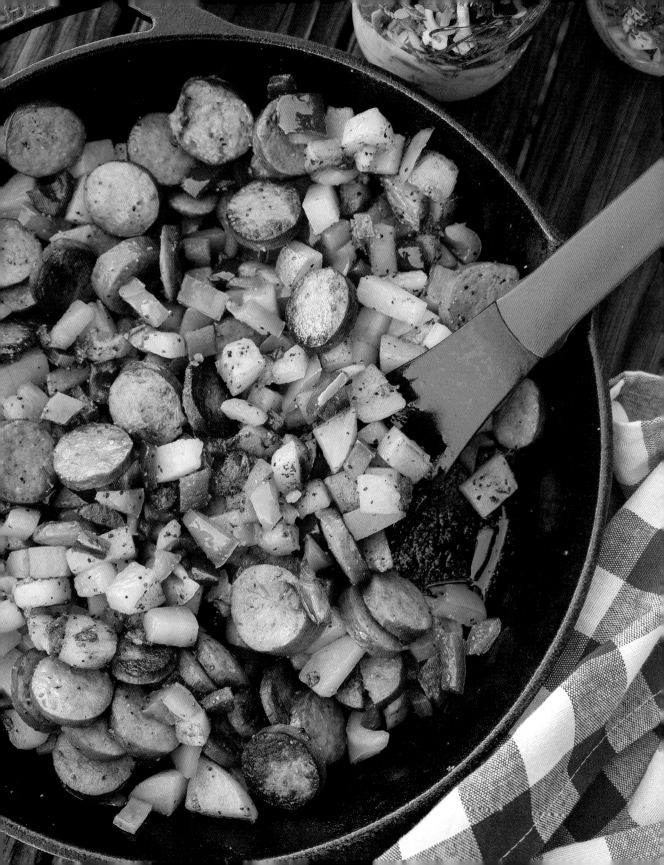

HAWAIIAN ROASTS

Makes 4 servings

INGREDIENTS

- 4 to 6 hot dogs, cut into pieces
- One 20-oz. can pineapple chunks, drained

Build a campfire. Slide hot dog pieces and pineapple chunks onto four pointed sticks. Hold sticks about 8" to 10" above hot coals. Cook until hot dogs are heated throughout, about 5 to 8 minutes.

HOBO BURGERS

Makes 1 serving

INGREDIENTS

- 1 hamburger patty
- 2 carrots, peeled and sliced
- 1 medium potato, cubed
- 1 small sweet onion, diced
- Salt and pepper to taste
- Garlic salt
- 2 T. butter

Build a campfire. Place hamburger patty, sliced carrots, cubed potatoes, and diced sweet onions on a large piece of aluminum foil. Season with salt, pepper, and garlic salt to taste. Place butter on top of ingredients. Wrap aluminum up and over ingredients to seal the packet. Wrap packet again in aluminum foil. Place wrapped packet directly in the coals of the campfire and cook for 45 minutes, until burger is cooked throughout. Using long tongs, remove packet from fire. Using a hot pad or oven mitt, slowly unwrap packet.

CAMPFIRE SAFETY FIRST

- Use long tongs and heavy oven mitts to move hot things at the fire.
- Cast iron cookware is very heavy when it's full of food. Get help to move it on and off the fire, especially if you hang pots on a tripod.
- Use a lid lifter to uncover Dutch ovens or to rotate the lids.

SWEET POTATO BLACK BEAN CHILI

Makes 4 servings

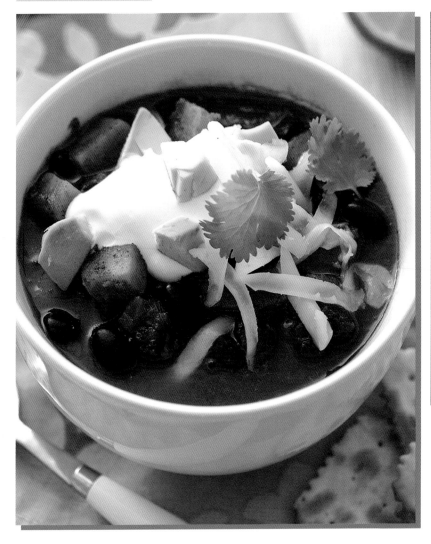

INGREDIENTS

- 2 tsp. olive oil
- 1 onion, diced
- 1 sweet potato, peeled and diced
- 1 tsp. garlic, minced
- 1 T. chili powder
- 1½ tsp. ground cumin
- ¼ tsp. ground chipotle powder
- 1 tsp. salt
- 1⅓ C. water
- 1 C. black beans, drained and rinsed
- 1 C. crushed tomatoes
- 2 tsp. lime juice
- Sour cream, avocado, Manchego cheese, and cilantro to top

Heat olive oil in a medium skillet over medium-high heat cooking fire. Add onion and sweet potato; sauté until the onion is slightly softened, stirring often. Add garlic, chili powder, ground cumin, ground chipotle powder, and salt; heat for 30 seconds, stirring constantly. Add water and bring to a simmer; cover, reduce heat to maintain a gentle simmer, and cook for 10 minutes, until tender.

Stir in black beans, crushed tomatoes, and lime juice; heat to simmering, stirring often. Cook until liquid is slightly reduced. Top with sour cream, avocado, Manchego cheese, and cilantro.

BOW WOW HOT DOGS

Makes 1 serving per hot dog

INGREDIENTS

- Hot dog
- Hot dog bun
- Fire-roasted salsa
- Corn
- Carrot, shredded
- Canadian bacon, diced
- Parmesan cheese, grated
- Shoestring potatoes

Cook hot dog as desired and place in bun. Top with salsa, corn, carrots, Canadian bacon, Parmesan cheese, and shoestring potatoes.

HOT DAWGS

Makes 1 serving per hot dog

INGREDIENTS

- Hot dog
- Hot dog bun
- Bacon, cooked and crumbled
- Black beans
- Red bell pepper, diced
- Hot sauce
- Mustard

Cook hot dog as desired and place in bun. Top with bacon, black beans, bell pepper, hot sauce, and mustard.

GARDEN PUP HOT DOGS

Makes 1 serving per hot dog

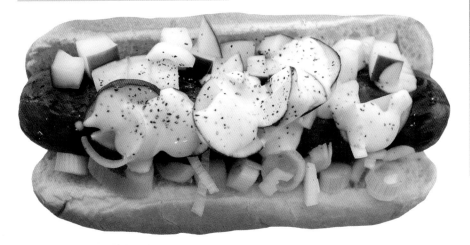

INGREDIENTS

- Hot dog
- Hot dog bun
- Cucumber, diced
- Radish, thinly sliced
- Green onion, thinly sliced
- Ranch dressing

Cook hot dog as desired and place in bun. Top with cucumber, radish, green onion, and ranch dressing.

CANINE KRAUT HOT DOGS

Makes 1 serving per hot dog

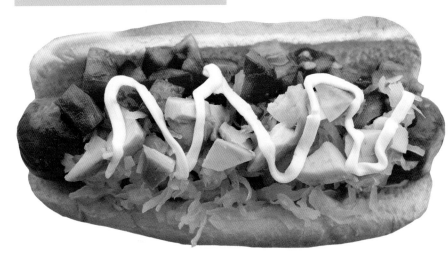

INGREDIENTS

- Hot dog
- Hot dog bun
- Tomato, diced
- Sauerkraut
- Avocado, diced
- Mayonnaise

Cook hot dog as desired and place in bun. Top with tomato, sauerkraut, avocado, and mayonnaise.

SOUTHWESTERN CHICKEN AND RICE DINNER

Makes 4 servings

INGREDIENTS

- 2 C. quick-cooking brown rice, uncooked
- 4 small boneless, skinless chicken breast halves
- ¼ C. ranch dressing
- 1½ tsp. chili powder
- Cayenne pepper
- ½ C. Cheddar cheese shredded
- 4 C. fresh broccoli florets
- 1 medium red pepper, chopped

In a medium bowl, combine uncooked rice and 1¾ cups water. Let mixture stand for 5 minutes. Cut four pieces of heavy-duty foil, each large enough to wrap around one chicken breast half with vegetables. Spray foil with nonstick vegetable spray. Place equal portions of soaked rice on the center of each piece of foil. Place one chicken breast half on top. Sprinkle ½ teaspoon chili powder and a little cayenne pepper on each. Drizzle ranch dressing evenly over chicken. Place tablespoons of shredded cheese, 1 cup broccoli, and a portion of the chopped red pepper on top. Wrap foil in a tent pack around each serving.

Place double-wrapped foil packs on medium-hot embers and cook for 18 to 25 minutes or until chicken is fully cooked. Move packs several times during cooking to obtain even heating.

ALL-AMERICAN BURGER

Makes 4 servings

INGREDIENTS

- 1½ lbs. ground beef
- 2 tsp. Worcestershire sauce
- 2 T. fresh chopped parsley
- 2 tsp. onion powder
- 1 tsp. garlic powder
- 1 tsp. salt
- 1 tsp. pepper
- 4 hamburger buns, split
- Ketchup, mustard, chopped onions, relish (optional)

Preheat grill or place grilling grate over campfire. In a medium bowl, combine ground beef, Worcestershire sauce, chopped parsley, onion powder, garlic powder, salt, and pepper. Mix lightly but thoroughly.

Shape mixture into four burgers, each about ½" thick. Place burgers on hot grate. Cook burgers over grill for 8 to 10 minutes, turning once, until thoroughly cooked to desired doneness. Remove burgers from grate and place burgers on buns. If desired, garnish burgers with ketchup, mustard, chopped onions, and/or relish.

Quick tip: Prepare burger mix at home by combining chopped parsley, onion powder, garlic powder, salt, and pepper. Pack mixture in an airtight container until ready to prepare recipe. Add ground beef and Worcestershire sauce at campsite.

CHICKEN ENCHILADA SKILLET

Makes 4 servings

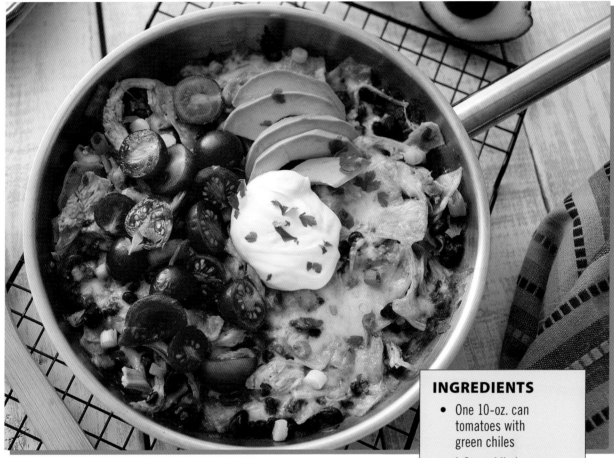

INGREDIENTS

- One 10-oz. can tomatoes with green chiles
- 1 C. enchilada sauce
- 1 C. black beans, drained and rinsed
- 2 boneless, skinless chicken breast halves
- Salt to taste
- 4 corn tortillas, cut into bite-sized pieces
- ½ C. Monterey Jack cheese, shredded
- Green onion, avocado, tomatoes, and sour cream to top

At home, in a medium oven-safe skillet over medium heat, combine tomatoes with green chiles, enchilada sauce, and black beans; bring to a simmer. Season chicken breast halves with salt; add to the skillet and cook over low heat for 20 minutes or until done, turning once.

Preheat your broiler. Shred the chicken and stir in corn tortillas (cut into bite-size pieces). Cover and simmer for 5 minutes. Uncover, transfer to foil baking dish, sprinkle with Monterey Jack cheese, and broil a minute or two until the cheese melts.

At camp, reheat foil pan in embers or on grate over campfire. Serve topped with green onion, avocado, tomatoes, and sour cream.

STUFFED FRANKFURTERS

Makes 8 servings

INGREDIENTS

- 8 frankfurters
- One 6-oz. pkg. stuffing mix, prepared
- 8 slices bacon

Preheat grill or place grilling grate over campfire. Using a knife, cut a lengthwise slit in each frankfurter. Stuff frankfurters with prepared stuffing. Wrap one slice of bacon around each frankfurter, holding the stuffing inside. Secure with toothpicks. Place frankfurters over grill and cook until bacon reaches desired crispness and frankfurters reach desired doneness. Remove toothpicks before serving.

Quick tip: Prepare stuffing at home and pack in an airtight container. Place in cooler until ready to prepare recipe.

FAVORITE CHEDDAR BURGER

Makes 4 servings

INGREDIENTS

- 1 lb. ground beef
- ⅓ C. steak sauce, divided
- 4 slices Cheddar cheese
- 1 medium onion, cut into strips
- 1 medium green or red bell pepper, cut into strips
- 1 T. butter or margarine
- 4 hamburger buns, split
- 4 slices tomato

Preheat grill or place grilling grate over campfire. In a medium bowl, combine ground beef and 3 tablespoons steak sauce. Mix lightly but thoroughly. Divide mixture into four equal parts. Shape each part into a burger, enclosing one slice of Cheddar cheese inside each burger, and set aside. Place a skillet on the hot grate and cook onions and bell pepper strips in butter, heating until vegetables are tender. Stir in remaining steak sauce and keep warm. Place burgers on hot grate. Cook burgers over grill for 8 to 10 minutes, turning once, until thoroughly cooked to desired doneness. Remove burgers from grate and place burgers on buns. Top each burger with a tomato slice and some of the cooked onions and peppers.

SAUSAGE PIZZA ON A STICK

Makes 12 servings

INGREDIENTS

- One 13.8-oz. tube refrigerated pizza dough
- Flour
- One 19-oz. pkg. cooked Italian sausage links, cut into chunks
- 12 whole fresh mushrooms
- 12 cherry tomatoes
- 1 onion, cut into 1" pieces
- 1 green bell pepper, cut into 1" pieces
- About 36 pepperoni slices
- Pizza sauce
- Parmesan cheese, grated

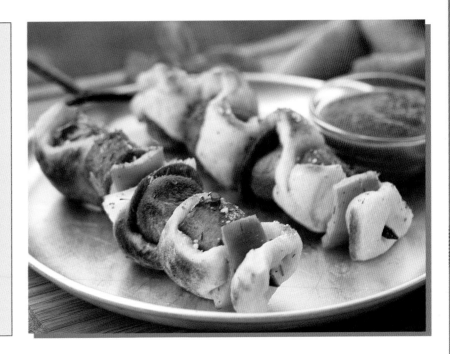

Unroll pizza dough on a lightly floured surface and cut crosswise into 12 strips about 1" wide. With a long metal skewer or campfire fork, pierce one end of a dough strip, then alternately thread sausage, mushrooms, tomatoes, onion, bell pepper, and pepperoni on skewer, threading the dough strip back onto the skewer several times in between to secure. Wrap end of dough strip around and over the skewer tip one last time. Repeat to make 11 more pizza sticks.

Cook slowly over hot embers for 10 to 15 minutes, turning several times, until vegetables are tender and crust is golden brown. Be patient—you want to make sure the dough is thoroughly cooked. Heat the pizza sauce in a saucepan over warm embers. Sprinkle skewers with cheese and serve with the warm pizza sauce.

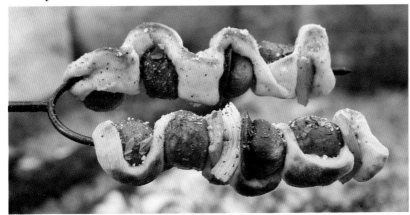

BLUE CHEESE AND BACON STUFFED BURGERS

Makes 4 burgers

INGREDIENTS

- 1½ lbs. ground beef
- 8 slices bacon, cooked and crumbled
- 1 C. blue cheese, crumbled

At home, make eight thin ground beef patties. Mix blue cheese and bacon. Spread blue cheese and bacon mix over four patties and top with other four patties. Press patties together at edges, sealing into four individual burgers. Wrap in heavy-duty foil and freeze.

At camp, fire when ready on grate over campfire.

MEATLOAF BURGERS

Makes 4 burgers

INGREDIENTS

- 1 lb. ground beef
- 1 egg
- ½ C. breadcrumbs or 4 slices torn fresh bread
- Salt and pepper to taste
- ½ C. onion, finely chopped or shredded
- 2 tsp. Worcestershire sauce
- 1 tsp. dry mustard

At home, beat the eggs and mix all ingredients together well using clean hands. Form four burgers, wrap in foil and freeze.

At camp, cook as desired on grate over campfire.

CHAPTER 3
GRILLED SANDWICHES

APPLE-CINNAMON GRILLED CHEESE

Makes 1 sandwich per 2 bread slices

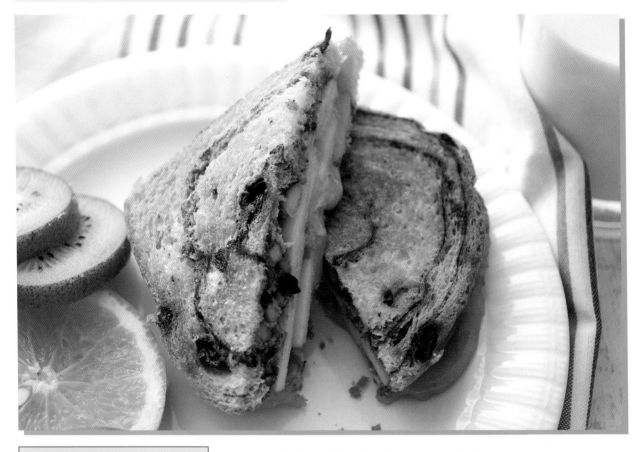

INGREDIENTS

- ⅓ C. chopped walnuts
- 1 T. honey
- 2 oz. cream cheese, softened
- ¼ tsp. cinnamon
- 2 slices cinnamon-raisin bread
- Granny Smith or golden delicious apple, thinly sliced
- 1 slice Cheddar cheese
- Butter

In a big skillet, cook and stir walnuts and honey over medium heat cooking fire for several minutes, until hot and lightly toasted (watch closely so they don't burn). In a small bowl, mix cream cheese with cinnamon; stir in the toasted walnuts and spread evenly over cinnamon-raisin bread. Top with several thin apple slices, Cheddar cheese, and another bread slice. Press gently.

Wipe out the skillet and heat over medium-low heat cooking fire. Butter the outside of each sandwich and toast in the hot skillet a couple of minutes on each side, until golden brown and the cheese is melted.

INSIDE-OUT JALAPEÑO POPPERS

Makes 1 sandwich per 2 bread slices

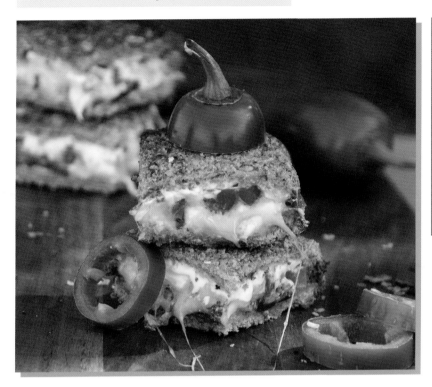

INGREDIENTS

- Corn flakes cereal
- Salt, pepper, garlic powder, and cumin
- Whole grain bread
- Cream cheese, softened
- Cheddar cheese
- Roasted red bell peppers, drained
- Jalapeño peppers

Grease a pie iron. Crush cereal; stir in seasonings. Coat a bread slice with cooking spray; dip into crumbs. Set coated side face down in iron.

Spread with a nice thick layer of cream cheese. Add Cheddar and roasted bell peppers. Slice jalapeños, remove seeds, and add to iron.

Spread cream cheese on a second bread slice; coat and dip the other side. Set bread on peppers, crumb side up. Close iron and trim; toast both sides.

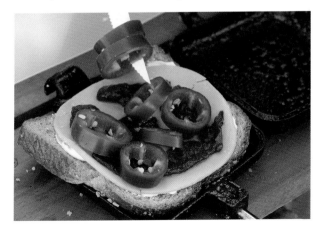

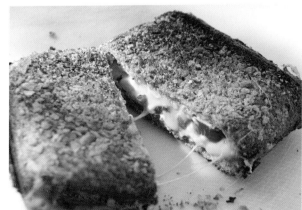

CHEESY SPINACH CALZONES

Makes 4 servings

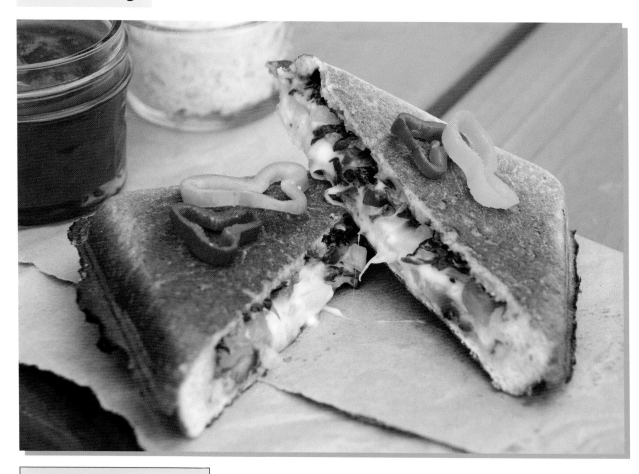

INGREDIENTS

- Refrigerated pizza dough
- Frozen spinach, thawed and drained
- Onions, chopped
- Bell peppers and mushrooms, sliced
- Garlic, minced
- Alfredo sauce
- Mozzarella cheese
- Salt and pepper

Coat a pie iron with cooking spray. Roll dough thin and cut into pieces to fit iron; press one piece inside. Pile on the spinach, chopped onions, and sliced peppers as shown.

Add sliced mushrooms, garlic, Alfredo sauce, and cheese; sprinkle with salt and pepper. Add another dough piece, close the iron, and cook over warm coals. Turn occasionally until dough is cooked and nicely browned.

SERVE WITH YOUR FAVORITE SAUCE FOR DIPPING!

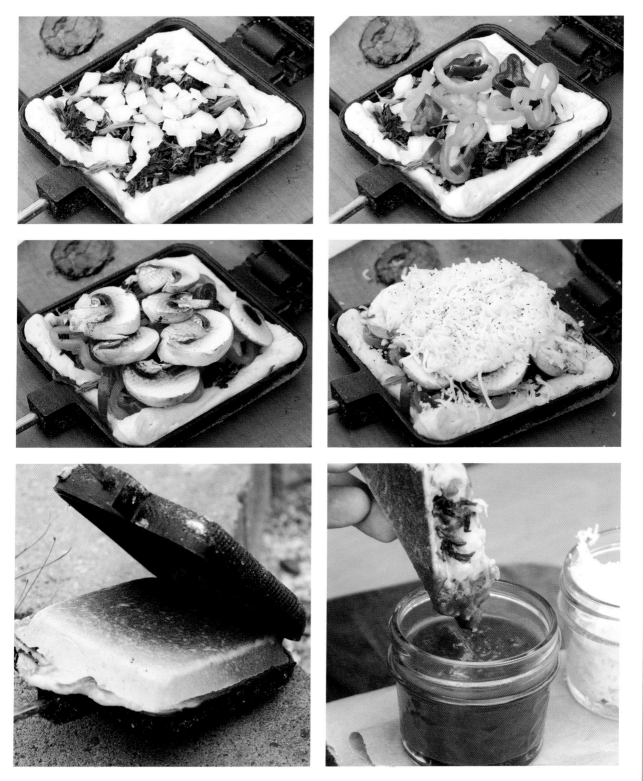

SLOPPY JOES

Makes 1 serving per 2 bread slices

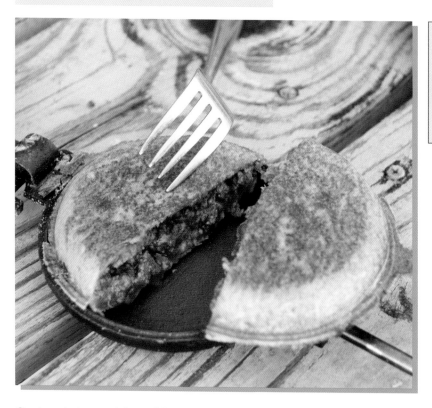

INGREDIENTS
- Potato bread
- 1 can sloppy joe mix
- 1 lb. ground beef, cooked
- Cheese, preferred variety

Coat a pie iron with cooking spray and set a slice of bread inside. Stir together sloppy joe mix and ground beef; spoon some onto the bread. Add cheese. Top with another slice of bread, close the iron, and trim off the excess. Hold above hot coals to get the filling good and hot.

TOASTED BLT

Makes 1 serving per 2 bread slices

INGREDIENTS
- Whole wheat bread
- Mayonnaise
- Tomatoes
- Bacon, cooked
- Lettuce leaves

Grease a pie iron and put a bread slice inside; smear with a little mayonnaise. Slice tomatoes and add a couple slices to the bread.

Add bacon before covering with another bread slice. Squeeze the iron shut, trim bread, and you're ready to cook. Hold in hot coals until toasted on both sides. Serve in a lettuce leaf.

PEANUT BUTTER WAFFLES

Makes 1 sandwich per 2 waffles

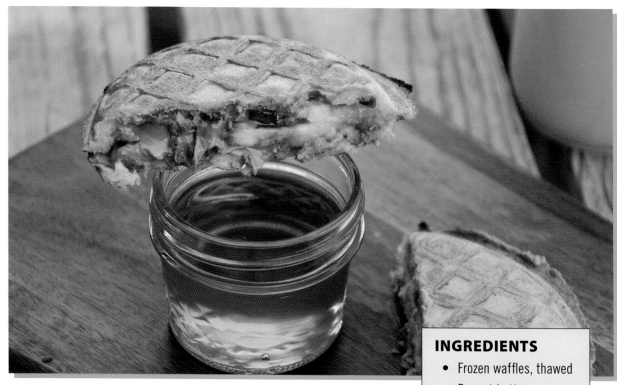

Place a waffle in a pie iron, spread with peanut butter, and top with banana slices.

Add chocolate-covered raisins and cover all with a second waffle. Close it up and cut off any waffle that might be poking outside the iron. Toast in hot coals. Serve with honey.

INGREDIENTS

- Frozen waffles, thawed
- Peanut butter
- Bananas
- Chocolate-covered raisins
- Honey

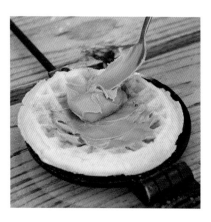
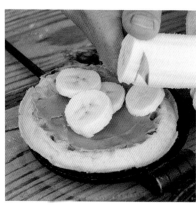
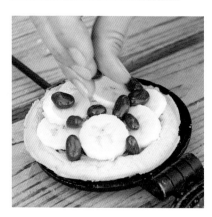

STUFFED TOAST

Makes 1 serving per 2 bread slices

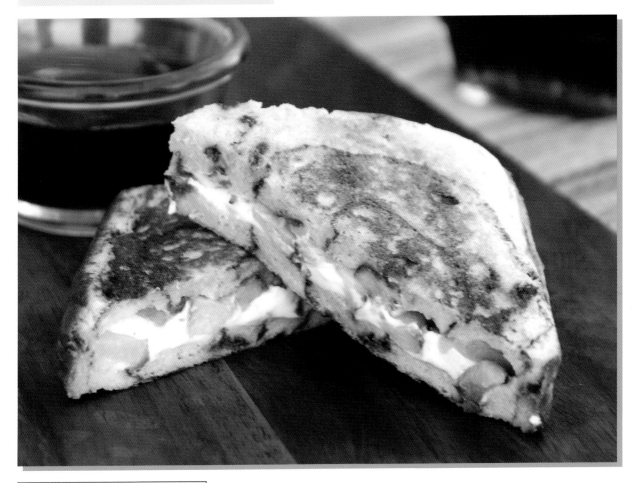

INGREDIENTS

- Egg
- Milk
- Cinnamon bread
- Cream cheese
- Chopped nuts
- Peaches, chopped
- Sugar

Mix egg with a little milk and dip both sides of a slice of cinnamon bread into it. Fit into one side of a greased pie iron. Add a few pats of cream cheese, chopped nuts, chopped peaches, and a sprinkle of sugar. Dip another bread slice in egg and set on top. Close iron; cook over hot coals until both sides are brown.

HOT CHICKEN SALAD PITAS

Makes 1 serving per pita

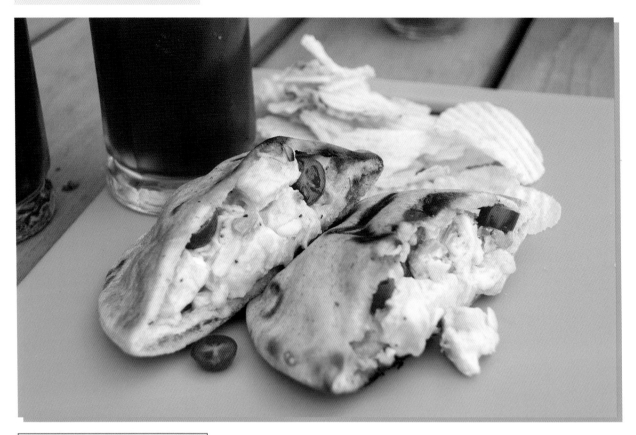

INGREDIENTS

- 2 C. chicken, cooked and cubed
- 1 C. celery, diced
- ½ C. slivered almonds
- 1 C. mayonnaise
- 2 T. fresh lemon juice
- 1 C. sharp Cheddar cheese, shredded
- Salt and black pepper to taste
- Pita breads
- Cherry tomatoes (optional)

At home, in a lidded storage container, stir together chicken, celery, almonds, mayonnaise, cheese, salt, and pepper. Chill to give the flavors a chance to blend.

At camp, stuff the chicken mixture into pitas and wrap in foil. Set in hot coals until heated through. Open them up and add tomatoes if you'd like.

Quick tip: By cutting your chicken, celery, and almonds into small pieces, you can store the chicken salad in a zippered plastic bag. Then at camp, you can simply cut off one corner of the bag and squeeze the chicken mixture into the pitas. Throw away the bag and there are no dirty dishes to deal with.

S'MORES HAND PIES

Makes 2 servings

INGREDIENTS

- Graham cracker crumbs
- Sugar
- Refrigerated pie crust
- Butter, melted
- Whipped cream cheese
- Mini marshmallows
- Chocolate chips

Mix cracker crumbs with a little sugar. Cut crust into pieces to fit pie iron; dip in butter, then in crumbs. Set in iron; add some cream cheese.

Toss in some marshmallows and chocolate chips. Dip a second crust piece in butter and crumbs; place on top. Close it up and set in warm coals until golden.

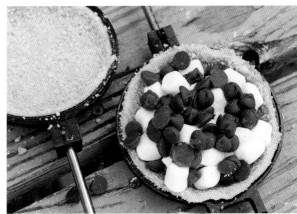

REUBENS ON THE FIRE

Makes 2 servings

INGREDIENTS

- 2 slices Swiss cheese
- 4 slices rye bread
- 4 to 6 slices corned beef
- 4 to 6 T. sauerkraut
- 2 to 4 T. Thousand Island dressing

Build a flaming campfire. Generously grease both sides of a pie iron with non-stick cooking spray. Assemble sandwich by placing one Swiss cheese slice on one slice of rye bread. Top with 2 to 3 slices of corned beef, 2 to 3 tablespoons of sauerkraut, 1 to 2 tablespoons Thousand Island dressing, and another slice of rye bread. Place sandwich on one side of the pie iron. Close iron and hold over flames for 3 to 5 minutes on each side. Remove iron from fire and open carefully with a hot pad or oven mitt. Repeat with remaining ingredients.

GRILLED CHEESE PERFECTION

Makes 1 serving

INGREDIENTS

- 1 T. butter, softened
- 2 slices white bread
- 2 slices American or Cheddar cheese
- 1 slice tomato

Build a flaming campfire. Generously grease both sides of a pie iron with non-stick cooking spray. Spread butter over one side of each slice of bread. Place one slice of bread, buttered side out, into one side of the pie iron. Layer with one cheese slice, tomato slice, and remaining cheese slice. Cover with remaining slice of bread, buttered side out. Close iron and hold over flames for 3 minutes on each side. Remove iron from fire and open carefully with a hot pad or oven mitt.

PHILLY CHEESESTEAKS

Makes 4 servings

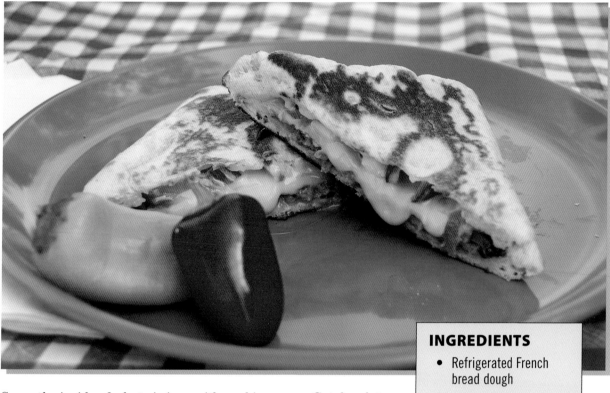

Spray the inside of a hot pie iron with cooking spray. Cut dough to fit in iron. Sandwich beef, cheese, onion, and pepper between two dough pieces.

Close the iron and put in the coals until bread is toasted brown. Check often so it doesn't burn.

INGREDIENTS

- Refrigerated French bread dough
- Deli roast beef
- Cheese slices
- Onion, sliced
- Bell pepper, sliced

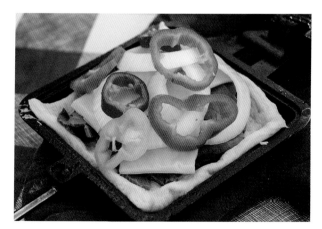

QUICK QUESADILLAS

Makes 1 serving per tortilla

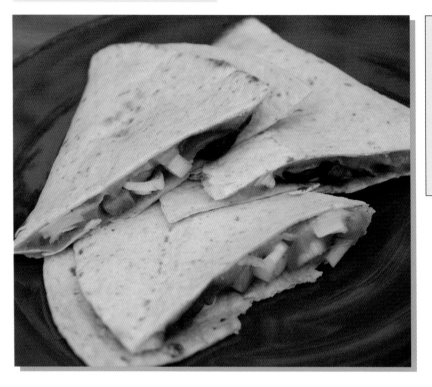

INGREDIENTS

- Fresh mushrooms, finely chopped
- Green onions, finely chopped
- Red peppers, finely chopped
- Flour tortillas
- Shredded cheese
- Any other toppings desired

First, cover half of a tortilla with cheese and veggies. Fold uncovered half over filling. Wrap in heavy-duty foil, double folding edges to seal. Lay pack directly on hot coals for 5 to 10 minutes or until cheese melts; remove with tongs.

Let cool slightly, then open pack. Cut into smaller pieces or just eat the whole thing.

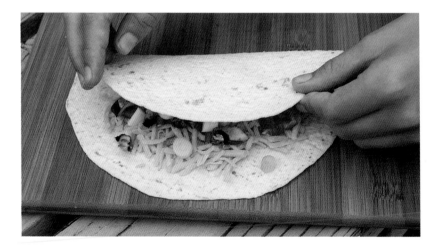

AVOCADO TUNA MELTS

Makes 2 servings

INGREDIENTS

- 1 avocado
- One 2.6-oz. pkg. tuna
- 2 T. onion, finely diced
- 2 T. pine nuts
- 4 slices rye bread
- 2 slices provolone cheese
- Tomato, sliced thin
- Sliced bacon, cooked

Cut avocado in half. Discard the pit and put the green innards into a bowl. Add tuna, onion, and pine nuts and stir to mix. Divide the mixture evenly among two slices of rye bread. Add one slice provolone cheese, a couple of thin tomato slices, and a couple of cooked bacon slices to each and cover with another slice of rye bread. Spritz the inside of a grill basket and the outside of the sandwiches with cooking spray. Set the sandwiches in the basket and hold over warm embers to slowly toast both sides, turning as needed.

HOT SOURDOUGH DELI SANDWICHES

Makes 4 servings

INGREDIENTS

- 8 slices sourdough bread
- 5 to 6 oz. thinly sliced deli ham
- 5 to 6 oz. thinly sliced smoked turkey
- 5 to 6 oz. thinly sliced pastrami
- 4 thin slices sweet onion
- ⅔ C. fresh mushrooms, sliced
- ⅔ C. green bell peppers, sliced
- 4 slices bacon, cooked and crumbled
- 4 slices provolone cheese

On four slices of bread, layer equal portions of ham, turkey, and pastrami slices. Place one slice of onion, a few mushrooms, and some green peppers on top of the meat. Sprinkle with crumbled bacon and add one slice of provolone cheese. Cover each with a remaining slice of bread. Cut four 14" pieces of heavy-duty foil. Wrap foil around each sandwich in a flat pack.

Place double-wrapped foil packs on medium-hot embers and cook for 8 to 10 minutes or until sandwiches are heated through. Turn packs over once during cooking.

CAMPFIRE COOKING CONSIDERATIONS

- Food will cook faster if you've got a really hot fire, the weather is warm and windless, the food is already at room temperature, or your portions are smaller.
- Avoid burned food. Use heavy-duty aluminum foil or a double layer of regular foil and move the food around every 5 to 10 minutes to prevent hot spots.
- Watch your fire. Don't set cookware and foil packs on big, scorching-hot coals or right in the flames. Instead, let logs burn down, then break them into smaller glowing chunks that can be moved around where you need them.

BABY REDS

Makes 8 servings

INGREDIENTS

- 16 baby red potatoes
- ¼ C. olive oil
- 1 tsp. each garlic powder, salt, and black pepper
- ½ lb. farmer's cheese, cut into sixteen 2" squares, about ¼" thick
- 2 T. chopped fresh chives
- Skewers (wooden skewers soaked in water for 30 minutes or metal skewers)
- Sour cream (optional)

At home, place potatoes in a big microwave-safe bowl with ¼ cup water. Microwave uncovered on high power for 10 minutes or until just tender; drain and set aside until cool enough to handle. Slice off one end of each potato to create a flat top.

In a big bowl, mix oil, garlic powder, salt, and pepper. Add potatoes and toss to coat. Cover and chill for 1 hour.

At camp, grease the grill rack and build fire to medium heat. Thread the chilled potatoes onto the skewers with all flat tops facing the same direction; set them on the grill rack, flat sides down. Cover with foil and cook about 5 minutes, until grill marks appear. Flip so flat tops face up and set a cheese square on each flat surface.

Cover with foil again and cook until the cheese melts. Sprinkle immediately with chives and pepper. Serve with sour cream if desired.

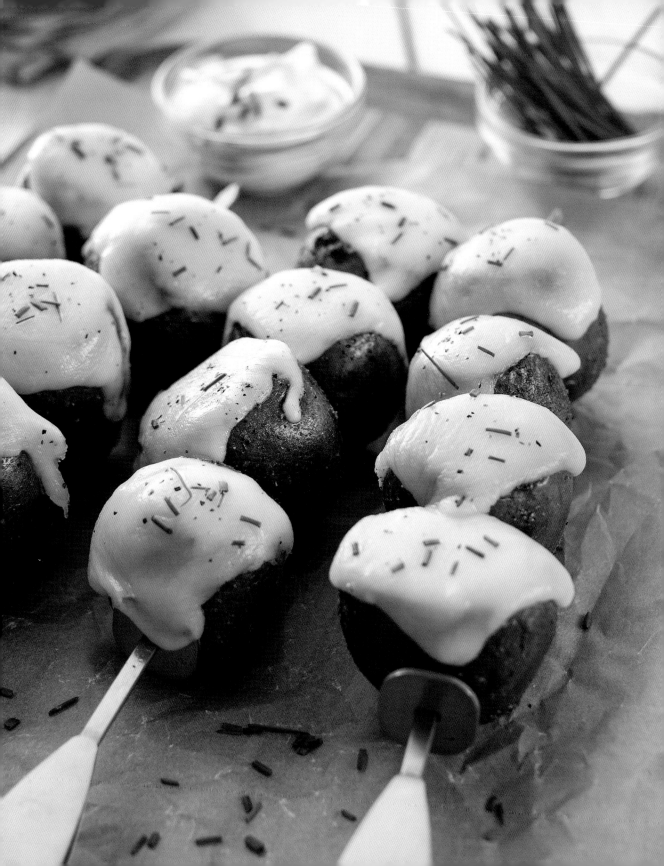

GRILLED POTATO SALAD

Makes 4 servings

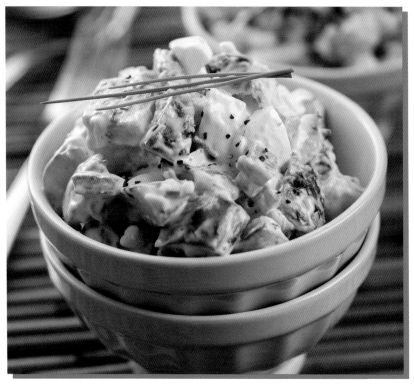

INGREDIENTS

- 1½ lbs. new potatoes, quartered
- 1 red or orange bell pepper, cut into 1" strips
- 1 celery rib
- 1 green onion
- 3 whole baby dill pickles
- ¾ C. mayonnaise
- 2 T. apple cider vinegar
- 1 T. yellow mustard
- A small handful of chopped fresh chives or dill
- 4 hard-boiled eggs, peeled and diced
- Salt and black pepper to taste

Heat grill or grate and a greased grill pan to medium heat. Cook the potatoes in boiling salted water for 5 minutes; drain and rinse with cold water.

Toss the potatoes, bell pepper, celery, green onion, and dill pickles on the hot grill pan and cook for 10 minutes or until everything has browned slightly and is just tender. Transfer the veggies to a cutting board and let cool.

In a big bowl, whisk together the mayonnaise, vinegar, mustard, and chives or dill. When the vegetables are cool, chop the potatoes into bite-size pieces and coarsely chop the remaining vegetables; dump into the bowl with the mayonnaise mixture. Add the eggs and stir until well coated. Season with salt and pepper.

MAKE AHEAD OR AT CAMP!

POTATO SALAD ONIONS

Makes 4 servings

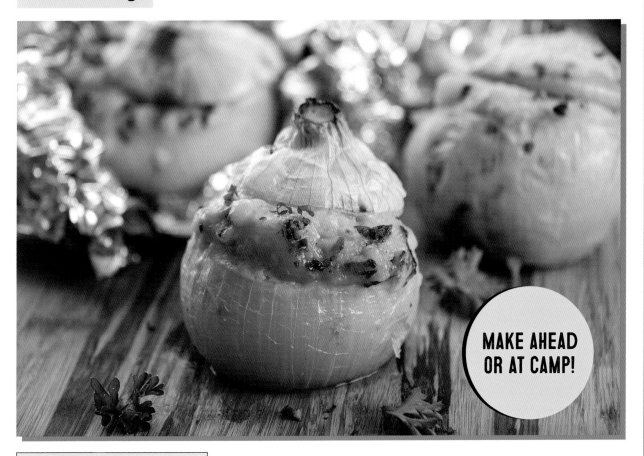

MAKE AHEAD OR AT CAMP!

INGREDIENTS

- 4 medium yellow onions
- 1 C. prepared potato salad
- ½ C. Cheddar cheese, shredded
- 4 strips bacon, cooked and crumbled

Build fire to medium heat for indirect cooking. Peel onions and cut off the top third of each, keeping the tops; trim the bottoms so they set flat. Dig out the center of each onion, leaving the two outer rings and the bottom intact. Save the portion you dug out for another recipe.

Stir together potato salad, Cheddar cheese, and bacon; spoon this mixture into the onion bowls and replace the tops. Wrap a piece of heavy-duty foil around each, leaving room inside for air circulation.

Grill on the cool side of the grate for 20 minutes, until tender. Open packet carefully to avoid steam.

ALFREDO MAC AND CHEESE

Makes 4 to 6 servings

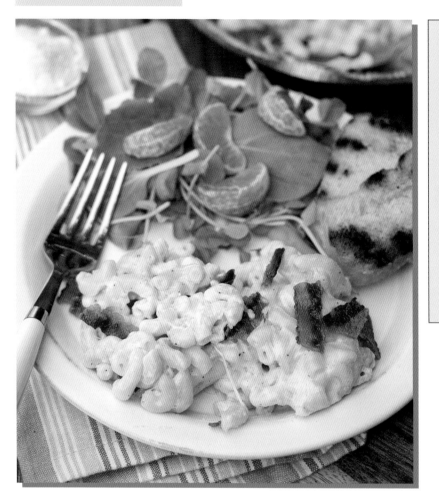

INGREDIENTS

- 1½ C. uncooked elbow macaroni
- 1 C. prepared Alfredo sauce
- ½ C. sharp Cheddar cheese, shredded
- ½ C. Parmesan cheese, grated
- ¼ C. mozzarella cheese, shredded
- Salt and black pepper to taste
- ¼ to ½ C. half-and-half, plus more for at camp
- Bacon, crumbled

At home, spritz an 8" foil pie pan with cooking spray and set aside. Cook macaroni according to package directions; drain and rinse. Stir in the Alfredo sauce, Cheddar, Parmesan, mozzarella, salt, and pepper. Stir in enough half-and-half to make things saucy. Transfer the mixture to the prepped pan, toss on the bacon, and cover tightly with foil that has also been spritzed with cooking spray; keep cool.

At camp, reheat covered mac and cheese on a rack over hot coals or on a grill until heated through, adding a little half-and-half or milk if needed to increase moisture. Serve immediately.

DUTCH OVEN CORNBREAD

Makes 6 servings

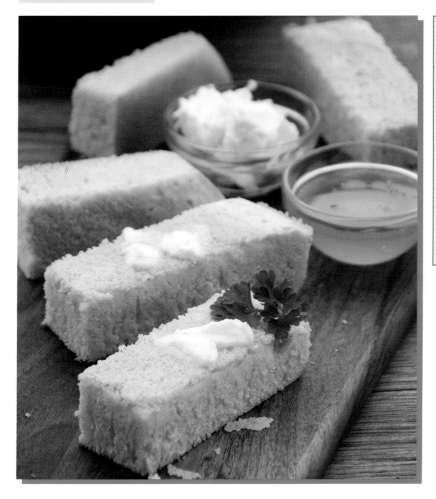

INGREDIENTS

- ½ C. flour
- ½ C. sugar
- 2 tsp. salt
- ½ tsp. baking soda
- 1½ C. yellow cornmeal
- 1 C. buttermilk
- 2 T. butter
- 2 eggs, beaten
- 1 C. milk
- Butter, honey, or syrup

At home, in a lidded container, combine the flour, sugar, salt, baking soda, and cornmeal.

At camp, add the buttermilk to the flour mixture and stir to blend. Melt the butter and add to the bowl. Whisk in the eggs and milk. Pour the batter into a greased 10" Dutch oven and set it on a ring of 7 hot coals; put 15 hot coals on the lid and bake for 35 to 45 minutes, until a toothpick comes out clean, rotating the pot and lid a few times. Near the end of cooking time, move a few coals toward the center of the lid to help with browning.

THREE-CHEESE MAC WITH BRUSSELS SPROUTS

Makes 4 to 6 servings

INGREDIENTS

- 1 C. uncooked elbow macaroni
- 2 tsp. vegetable oil
- ½ small shallot, chopped
- ½ tsp. garlic, minced
- ¼ lb. Brussels sprouts, trimmed and sliced
- 1 T. butter
- 1 T. flour
- ¾ C. milk
- 3 T. half-and-half
- ¾ C. fontina cheese, shredded
- ½ C. white Cheddar cheese, shredded
- 1½ T. Parmesan cheese, grated
- Pinch of ground nutmeg
- 3 strips bacon, cooked and chopped
- 1 T. dry breadcrumbs
- 2 T. panko breadcrumbs

At home, preheat oven to 375°F. Cook the macaroni in a 9" oven-safe skillet to al dente according to package directions; drain and set aside. Dry out the skillet.

Heat the oil in the same skillet over medium-low heat; add the shallot, garlic, and Brussels sprouts. Sauté for 5 minutes, until softened, stirring often; add to the cooked macaroni.

Melt the butter in the empty skillet. Whisk in the flour and cook a minute or so, until golden brown. Whisk in the milk and half-and-half; cook over medium heat until slightly thickened, stirring constantly. Add the fontina, Cheddar, Parmesan, and nutmeg, stirring until the cheese is melted.

Dump the macaroni, sprouts, and ⅓ of the bacon into the skillet and stir until well combined. Sprinkle both kinds of breadcrumbs over the top and toss on the remaining bacon. Bake uncovered 30 to 35 minutes or until golden brown and bubbly. Transfer to a foil pan and wrap in heavy-duty foil. Freeze.

At camp, place in coals or on a grate over fire to heat and eat.

CHEESY JALAPEÑO LOAF

Makes 6 servings

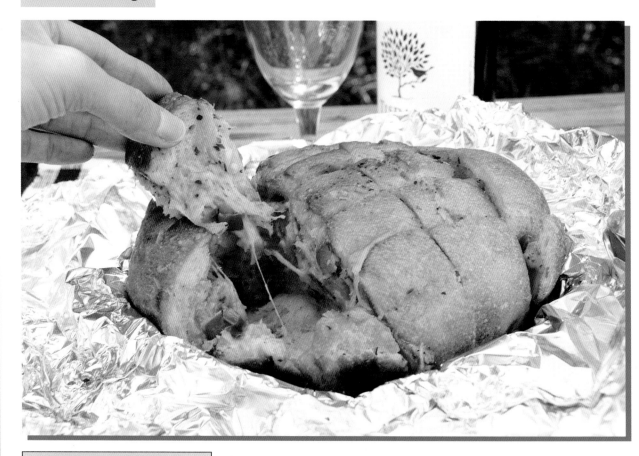

INGREDIENTS

- One 8-oz. pkg. shredded sharp Cheddar cheese
- ¼ C. pickled jalapeños, drained and chopped
- ½ C. green onions, chopped
- ¼ C. butter, melted and cooled slightly
- 1 loaf unsliced round crusty bread, such as ciabatta
- Sea salt and dried oregano to taste

Stir together cheese, jalapeños, onions, and butter (you can do this right in the cheese bag, if you'd like).

Coat a large piece of foil with cooking spray and set the bread in the center. Slice bread lengthwise and crosswise without cutting through the bottom; stuff cheese mixture evenly into cuts. Sprinkle with salt and oregano. Wrap foil around bread and seal edges.

Place in a foil pan and set the whole thing on a cooking rack over hot coals. Heat until cheese is melted, rotating occasionally.

QUICK SWEET POTATOES AND APPLES

Makes 6 servings

Heat grill or grate over campfire to medium heat. Cut one large piece of heavy-duty aluminum foil; spray with nonstick cooking spray. Slice sweet potatoes on foil. In a small bowl, combine apple butter, brown sugar, 1 tablespoon water, and cinnamon. Spoon over potatoes; dot with butter. Fold in sides of foil and seal well. Grill packet, seam side up, for 15 to 20 minutes or until heated through.

INGREDIENTS

- One 18-oz. can sweet potatoes, drained
- ¼ C. apple butter
- 2 T. brown sugar
- ¼ tsp. ground cinnamon
- 1 T. butter

BASIC GRILLED POTATO PACKETS

Makes 4 to 6 servings

Heat grill or grate over campfire to medium heat. Spray a sheet of heavy-duty aluminum foil with nonstick cooking spray. On center of aluminum foil, combine potatoes, salt, and black pepper. Dot with butter or drizzle with oil. Fold foil around potatoes, securely sealing all edges to make a packet. Cook 20 to 30 minutes or until tender, carefully flipping packet once halfway through cooking time.

INGREDIENTS

- 1½ to 2 lbs. potatoes, peeled and thinly sliced
- Salt and black pepper to taste
- 2 T. butter or olive oil

BBQ BAKED BEANS

Makes 15 to 20 servings

Heat grill or grate over campfire to medium heat. In a large bowl, combine ground beef, soup mix, barbecue sauce, 1 cup cold water, mustard, vinegar, brown sugar, and beans. Pour into a heat-proof pan and cover with heavy-duty foil. Cook about 90 minutes.

INGREDIENTS

- 2 lbs. ground beef, browned and drained
- One 1-oz. pkg. dry onion soup mix
- One 12-oz. bottle barbecue sauce
- ¼ C. prepared yellow mustard
- 1 T. vinegar
- ¼ C. brown sugar
- Two 15-oz. cans pork and beans

HERBED NEW POTATOES

Makes 8 servings

Cut eight 10" pieces of heavy-duty foil. Brush each piece with olive oil. Wash and slice the potatoes about ¼" thick. Place an equal portion of sliced potatoes on each piece of foil. Slice the onion into rings about ¼" thick. Separate the rings and place an equal portion on top of the potatoes in each pack.

Sprinkle vegetables with rosemary, salt, pepper, and cayenne pepper. Crimp foil edges enough to hold in liquids. Drizzle vegetables with remaining olive oil. Wrap foil in a tent pack around each serving.

Place double-wrapped foil packs on medium embers and cook for 15 to 20 minutes or until potatoes are tender. Turn packs over several times during cooking.

INGREDIENTS
- ⅓ C. olive oil
- 2 lbs. new potatoes
- ½ medium yellow onion or sweet Spanish onion
- ½ tsp. dried rosemary
- ¾ tsp. salt
- ½ tsp. pepper
- Pinch of cayenne pepper

BACON CORN MUFFINS

Makes 12 muffins

Heat grill or grate over campfire to high heat. In a medium heat-proof skillet set on the grate, cook bacon until crisp. Drain and crumble. Line a 12-cup muffin tin with paper liners. In a large bowl, whisk together flour, cornmeal, sugar, baking powder, salt, baking soda, black pepper, and cayenne pepper. Stir in corn, scallions, and bacon. In a medium bowl, whisk together eggs, sour cream, and butter. Fold the wet ingredients into the dry ingredients until just blended. Pour batter into muffin cups. Place muffin tin on the grate, opposite the coals. Close grill lid or cover muffin tin with foil tent and bake 20 minutes or until done.

INGREDIENTS
- 5 strips bacon
- 1 C. flour
- 1 C. yellow cornmeal
- ¼ C. sugar
- 2 tsp. baking powder
- 2 tsp. salt
- ½ tsp. baking soda
- ½ tsp. black pepper
- Pinch cayenne pepper
- 1½ C. frozen corn, thawed
- 4 large scallions, finely chopped
- 2 eggs
- 1 C. sour cream
- ¼ C. butter, melted

BRIE BREAD

Makes 6 servings

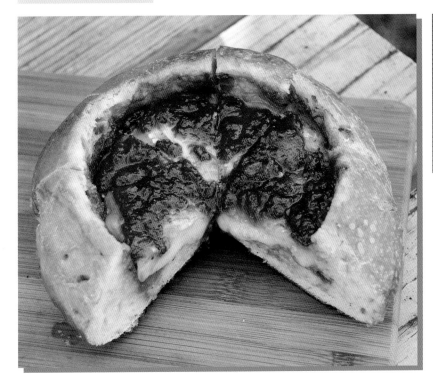

Remove top of loaf and hollow out bread. Add some jam, the cheese, more jam, and a little syrup and brown sugar.

Replace top of bread before wrapping loaf in heavy-duty foil. Set in a foil pan on a grate over hot coals for 20 minutes or until hot and gooey. Slice bread and serve warm.

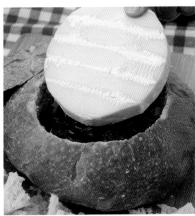
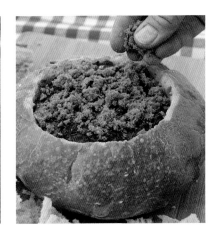

BACON-WRAPPED ONIONS

Makes 6 servings

INGREDIENTS

- 3 large sweet white onions
- 6 strips bacon
- 1 T. butter

Heat grill or grate over campfire to medium heat. Peel onions. Using a small, sharp knife, carefully remove a 1" x 1" core from the top of each onion and discard. Place 1 teaspoon butter in each onion. Wrap two strips of bacon around each onion, securing with toothpicks. Place each onion on a square of heavy-duty aluminum foil and bring the edges loosely together at the top. Grill about 45 minutes, or until onions are tender when pierced with the tip of a knife. Cool for a few minutes before removing from foil.

BASIC POTATOES IN FOIL

Makes 2 to 4 servings

INGREDIENTS

- 2 large potatoes
- 1 to 2 medium onions
- Salt and pepper
- Garlic powder
- 2 T. butter, cut into pieces

Cut one piece of heavy-duty foil 15" long. Spray foil with nonstick vegetable spray. Peel and slice the potatoes. Cut onions into small pieces. Place potatoes and onions on foil. Sprinkle with salt, pepper, and garlic powder to taste. Arrange pieces of butter over vegetables. Wrap foil around vegetables in a tent pack.

Place double-wrapped foil pack on medium embers and cook for 20 to 30 minutes or until potatoes are tender. Turn pack over several times during cooking.

Grilling in foil keeps moisture in the food and saves on clean-up. Use heavy-duty aluminum foil or a double layer of regular foil to prevent rips and help protect food from high temperatures.

STUFFED CHEESE BREAD

Makes 6 servings

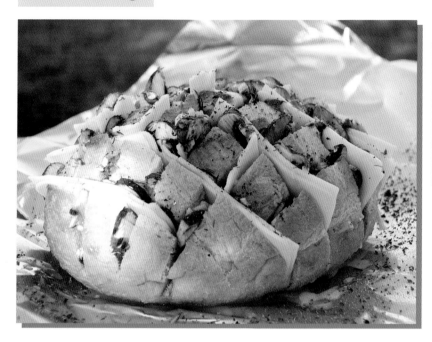

INGREDIENTS
- 1 sourdough loaf
- Mozzarella cheese
- Mushrooms
- Butter, melted
- Garlic powder
- Italian seasoning

Slice the bread lengthwise and crosswise without cutting through the bottom. Set the loaf in the center of a large double layer of foil sprayed with cooking spray.

Slice cheese and mushrooms and load into cuts. Drizzle butter into the cuts and sprinkle with garlic powder and Italian seasoning.

Seal foil around loaf; set packet in a foil baking pan and place the whole thing on a grate over hot coals. Cook for 20 to 25 minutes or until cheese is melted.

Rotate bread halfway through cooking time. Open packet and serve!

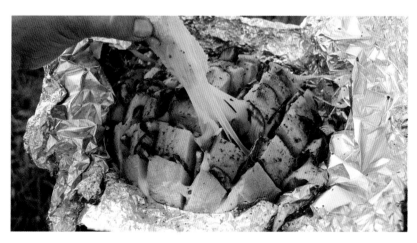

GRILL-BAKED SWEET POTATOES

Makes 6 servings

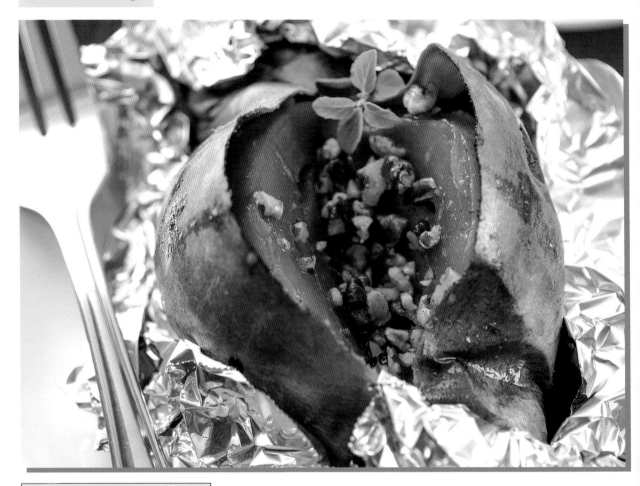

INGREDIENTS

- 6 sweet potatoes
- ¼ C. butter
- ¼ C. maple syrup
- 3 T. chopped pecans
- ⅛ tsp. each cinnamon, cayenne pepper, and salt

Heat grill or grate over campfire to medium heat, for indirect cooking. Wrap sweet potatoes individually in foil and place on the cool side of the grill about an hour, until tender.

In a saucepan, melt butter. Add maple syrup, chopped pecans, cinnamon, cayenne pepper, and salt. Heat to simmering. Drizzle baked sweet potatoes with the warm butter-pecan mixture.

GARLIC AND ONION ASPARAGUS

Makes 4 servings

INGREDIENTS

- 1 T. olive oil
- ½ tsp. garlic salt
- ½ tsp. onion powder
- 1 lb. asparagus, trimmed
- Butter

Mix olive oil, garlic salt, and onion powder in a foil pan. Add asparagus, turning to coat; arrange in a single layer. Top with several pats of butter, and set the pan on the hot grill for 6 to 8 minutes or until crisp-tender. Toss and serve.

CAULIFLOWER WITH PARMESAN

Makes 4 servings

INGREDIENTS

- 1 head cauliflower
- ¼ C. butter, melted
- 1½ tsp. seasoned salt
- ¼ C. Parmesan cheese, shredded or grated

Heat grill or grate over campfire to medium heat. Break cauliflower into florets and put into a bowl. Add butter, seasoned salt, and Parmesan cheese; toss to coat. Dump the mixture onto a big piece of heavy-duty foil. Fold up the foil, leaving room inside for air circulation, and set on the hot grill. Cook for 10 to 15 minutes or until crisp-tender. Open carefully, toss, and serve.

BROCCOLI CASSEROLE

Makes 4 servings

INGREDIENTS

- 6 C. broccoli florets
- One 10.75-oz. can cream of mushroom soup
- ¼ C. mayonnaise
- 1 T. Worcestershire sauce
- Salt and pepper
- ½ C. Cheddar cheese, shredded
- ⅔ C. dry seasoned bread stuffing mix

Cut one piece of wide heavy-duty foil 24" long. Spray foil with nonstick vegetable spray. Place broccoli in the middle of foil. Crimp foil edges enough to hold in liquids. In a small bowl, combine the soup, mayonnaise, Worcestershire sauce, salt, and pepper; mix well. Pour mixture over broccoli. Sprinkle cheese over broccoli and top with stuffing mix. Wrap foil around broccoli in a tent pack.

Place double-wrapped foil pack on medium-hot embers and cook for 10 to 20 minutes or until broccoli is tender. Turn pack several times during cooking.

CITRUS BROCCOLI AND CARROTS

Makes 6 to 8 servings

INGREDIENTS

- ¼ C. orange marmalade
- ½ tsp. salt
- 1½ C. baby carrots
- 6 C. broccoli florets
- One 11-oz. can mandarin oranges, drained
- ¼ C. cashews

In a large bowl, mix orange marmalade with salt. Cut each carrot in half lengthwise. Add the carrots and broccoli to marmalade mixture and stir well to coat. Cut one piece of wide heavy-duty foil 24" long. Spray foil with nonstick vegetable spray. Place vegetable mixture in the middle of the foil piece. Wrap foil around vegetables in a tent pack.

Place double-wrapped foil pack on medium embers and cook for 8 to 15 minutes or until vegetables are tender. Rotate pack several times during cooking.

After cooking, open pack and stir in mandarin oranges. Sprinkle cashews on top before serving.

SIMPLY CARROTS

Makes 4 servings

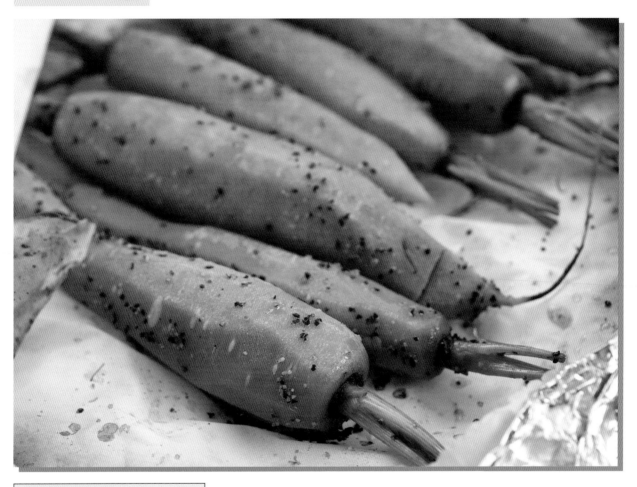

INGREDIENTS

- 1 lb. small carrots
- 2 tsp. grapeseed oil
- Salt and black pepper

Heat grill or grate over campfire to medium-high heat. Place carrots on parchment paper-lined heavy-duty foil, drizzle with grapeseed oil, and season well with salt and black pepper. Fold up the foil, leaving room inside for air circulation, and set on the hot grill for 15 minutes or until crisp-tender. Open carefully, toss, and serve.

RAINBOW PINWHEELS

Makes 4 servings

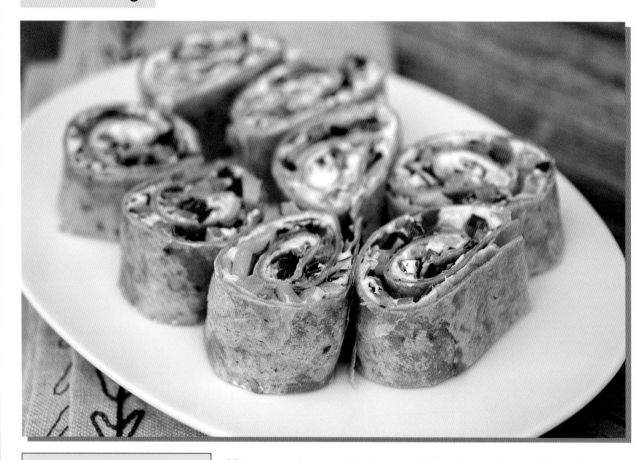

INGREDIENTS

- ⅔ C. whipped cream cheese
- 1 T. dry ranch dressing
- Two 10" spinach-herb tortillas
- ¼ C. carrot, finely diced
- ¼ C. red and yellow bell pepper, finely diced
- ¼ C. baby spinach, chopped
- ¼ C. purple cabbage, shredded

Mix cream cheese with dry ranch dressing and spread evenly over one side of each spinach-herb tortilla. Toss together carrot, bell pepper, baby spinach, and purple cabbage and distribute evenly among the tortillas, leaving a 1" border. Roll up the tortillas tightly, wrap individually in plastic wrap, and chill. Then just slice and serve.

MAKE AHEAD OR AT CAMP!

ARTICHOKES AND CARROTS

Makes 6 servings

INGREDIENTS

- 8 carrots
- One 15-oz. can artichoke hearts
- Juice of 1 lemon
- 1 T. sugar
- ¼ C. butter, melted
- 2 T. chopped parsley
- 1 tsp. salt
- Pepper

Peel carrots and cut them into strips. Drain artichoke hearts and cut each into four pieces. In a small bowl, combine lemon juice, sugar, melted butter, parsley, salt, and pepper. Stir to mix well. Cut six 12" squares of heavy-duty foil. Place equal portions of the carrots and artichokes on each piece. Crimp edges of foil enough to hold in liquids. Pour an equal portion of the butter mixture over vegetables. Wrap foil in a tent pack around each serving.

Place double-wrapped foil packs on medium embers for 18 to 25 minutes or until carrots are tender. Rotate pack several times during cooking.

ASIAN ASPARAGUS

Makes 3 to 4 servings

INGREDIENTS

- 2 T. olive oil or sesame oil
- Dash of cayenne pepper
- 1 tsp. brown sugar
- 2 tsp. soy sauce
- 1 lb. fresh asparagus spears, trimmed

In a medium bowl, combine the olive oil, cayenne pepper, brown sugar, and soy sauce. Add the asparagus and toss together until well coated. Cut one piece of foil large enough to wrap around asparagus. Spray foil with nonstick vegetable spray. Crimp foil edges enough to hold in liquids. Place coated asparagus on foil. Wrap foil around asparagus in a tent pack.

Place double-wrapped foil pack on warm embers and cook for 10 to 15 minutes or until asparagus is tender. Rotate pack several times during cooking.

CAULIFLOWER WITH SPICY CHEESE SAUCE

Makes 4 servings

INGREDIENTS

- 4 C. cauliflower florets
- 4 oz. pasteurized processed cheese sauce
- 1 tsp. hot pepper sauce
- ¼ tsp. crushed red pepper flakes (optional)

Cut one piece of foil large enough to wrap around all the cauliflower. Spray foil with nonstick vegetable spray. Place cauliflower pieces in the center of foil. In a small bowl, mix the cheese sauce, hot pepper sauce, and red pepper flakes.

Spread cheese sauce over the cauliflower. Wrap foil around cauliflower in a tent pack.

Place double-wrapped foil pack on medium-hot embers and cook for 8 to 15 minutes or until cauliflower is tender. Rotate pack several times during cooking.

MOZZARELLA AND TOMATO SKEWERS

Makes 6 to 8 servings

INGREDIENTS

- 1 loaf crusty bread
- 12 oz. grape tomatoes
- 8 oz. fresh mozzarella cheese, cut into 1" chunks
- ¼ C. olive oil
- 2 tsp. chopped fresh basil
- 1 tsp. garlic powder
- Salt to taste
- Black pepper to taste
- Skewers (wooden skewers soaked in water for 30 minutes or metal skewers)

Heat grill or grate over campfire to high heat. Slice bread into bite-size pieces. Thread bread, tomatoes, and cheese on skewers. In a small bowl, combine oil, basil, and garlic. Brush over both sides of skewers. Sprinkle with salt and black pepper. Grill 1 to 2 minutes on each side until bread is toasted.

ITALIAN SNAP PEAS

Makes 4 servings

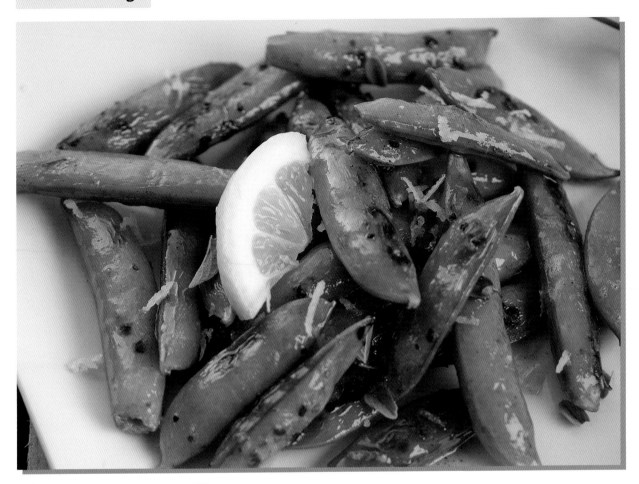

INGREDIENTS

- 1 lb. snap peas
- 1 green onion, sliced
- 1½ T. butter, melted
- 1½ tsp. fresh oregano, chopped
- 1½ tsp. lemon zest
- ¾ tsp. salt
- ½ tsp. black pepper

Heat grill or grate over campfire to medium heat. Line the grill rack with heavy-duty foil and arrange snap peas on the foil; toss on green onion. Drizzle with butter and sprinkle with oregano, lemon zest, salt, and pepper. Cook about 8 minutes or until crisp-tender. Toss and serve.

LAYERED VEGGIE SALAD

Makes 8 servings

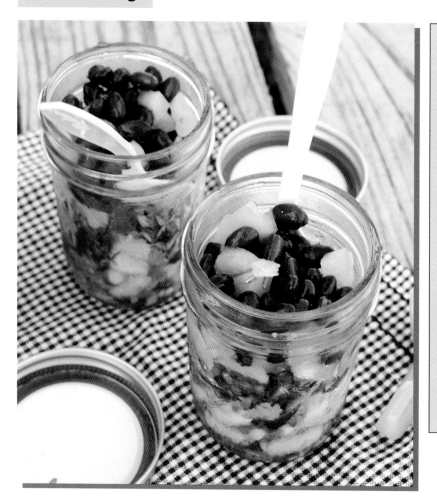

INGREDIENTS

- ⅓ C. apple cider vinegar
- ⅓ C. sugar
- ¼ C. olive oil
- 1½ tsp. salt
- ¼ tsp. black pepper
- ½ red onion, finely chopped
- 2 celery stalks, finely chopped
- One 15-oz. can cannellini beans, rinsed and drained
- 1 C. chopped fresh parsley
- One 15-oz. can kidney beans, rinsed and drained
- 1 yellow bell pepper, chopped
- One 15-oz. can black beans, rinsed and drained
- 1 T. finely chopped fresh rosemary

At home, whisk together vinegar, sugar, oil, salt, and pepper; divide evenly among eight half-pint fruit jars. In each jar, layer remaining ingredients. Tighten lids and pack in cooler.

At camp, shake jars to distribute dressing. Grab a fork and eat right out of the jars. These will keep for several days.

FOILED CABBAGE

Makes 4 servings

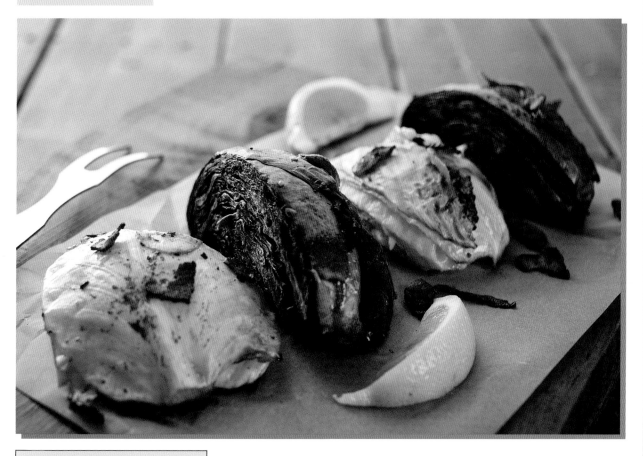

INGREDIENTS

- 1 cabbage, any color
- Onion, sliced
- Bacon, cooked and crumbled
- Worcestershire sauce
- Lemon juice
- Paprika, salt, and black pepper to taste

Heat grill or grate over campfire to medium heat. Cut cabbage into four wedges, discard the core and outer leaves, and set the wedges on big piece of greased heavy-duty foil. Toss in some onion slices and a few handfuls of cooked bacon pieces. Add several dashes of Worcestershire sauce and a little lemon juice. Sprinkle with paprika, salt, and black pepper.

Fold up the foil, leaving room inside for air circulation; set on the hot grill for 15 to 20 minutes, until tender. Open carefully to avoid steam.

VEGGIE PIZZA

Makes 1 pizza

INGREDIENTS

- 2 cans refrigerated crescent rolls
- 2 bricks cream cheese
- 1 packet ranch seasoning
- 6 to 8 C. cheese of choice, shredded
- 6 to 8 C. colorful raw vegetables, chopped

At home, grease large baking sheet. Arrange crescent rolls flat on sheet to form crust layer. Pierce with fork. Bake to desired crispness. Cool. Mix softened cream cheese with ranch seasoning. Spread over cooled crust. Top with layer of shredded cheese. Mix chopped vegetables and spread over cheese layers. Cover with waxed paper sheet and press firmly. Refrigerate. Cut with pizza wheel and wrap pieces individually for easy packing in cooler.

At camp, serve cold.

LAYERED LETTUCE

Makes 8 servings

INGREDIENTS

- Salad dressing
- Lettuce
- Cherry tomatoes
- Snap peas
- Carrots, chopped or shredded
- Celery, chopped
- Baby corn spears

At home, divide desired salad dressing evenly among eight ½-pint fruit jars. In each jar, layer the remaining ingredients, starting with the snap peas and cherry tomatoes and ending with the lettuce.

At camp, shake jars to distribute dressing. Grab a fork and eat right out of the jars. These will keep for several days.

PICNIC FOIL PACK

Makes 6 servings

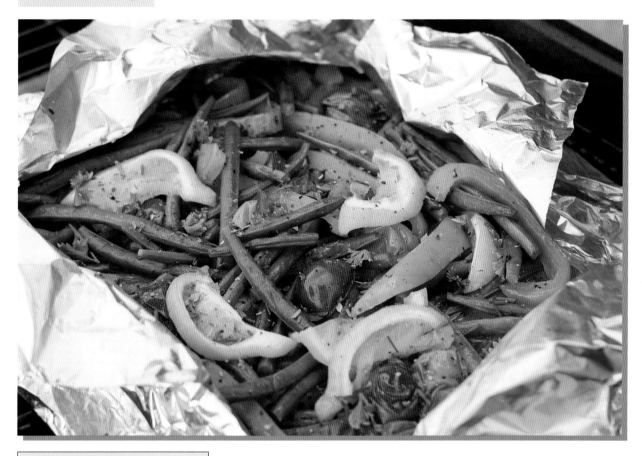

INGREDIENTS

- 1 lb. green and/or yellow wax beans
- 1 lb. cherry tomatoes
- 1 orange bell pepper, sliced
- 1 tsp. each coarse salt and black pepper
- 3 T. grapeseed oil, divided
- 1 lemon, halved, divided
- 1 T. each chopped fresh parsley and chives
- 1 tsp. dried tarragon

Heat grill or grate over campfire to medium heat. Dump the beans, tomatoes, and bell pepper into a bowl and add the salt, pepper, and 2 tablespoons oil; toss to coat. Transfer the mixture to a large piece of heavy-duty foil. Cut one lemon half into slices and arrange on top of the vegetables.

Wrap the foil around the vegetables, folding up the edges to create a packet and leaving space inside for air circulation. Place the packet on the grill and cook for 15 to 20 minutes or until just tender. Open carefully to avoid steam. Drizzle the remaining 1 tablespoon oil over the top, and sprinkle with the parsley, chives, and tarragon. Squeeze the juice from the other lemon half over all.

CAMPFIRE GREEN BEANS

Makes 6 servings

INGREDIENTS

- 2 T. olive oil
- 1 Vidalia onion, chopped
- 1 clove garlic, minced
- ¼ C. slivered almonds
- Three 14.5-oz. cans French cut green beans, drained
- Salt and pepper to taste

Heat grilling grate over campfire. Place olive oil, chopped onions, minced garlic, and slivered almonds in a cast iron skillet and place skillet over heat. Sauté mixture until onions are tender, about 5 minutes. Add drained green beans to skillet and season with salt and pepper to taste. Cook until green beans are heated throughout.

GRILL SUCCESS

- When using saucepans or bakeware on a grill or grate, keep in mind the bottom may get charred. Be sure to use heat-proof cast iron, stainless steel, or disposable foil pans.
- When grilling root vegetables like potatoes and sweet potatoes, par-boiling them first cuts down on grilling time and reduces the risk of burning the outside before the inside gets done.
- Clean the grates well before cooking sides and sweets. You don't want your pineapple to taste like a burger.
- Choose fruits and veggies that are ripe but not too soft so they'll hold up well on the grill.
- Grease the grates before you start the grill or place over the campfire to avoid flare-ups.
- When grilling smaller pieces like asparagus or green beans, use a grill pan or side-by-side skewers to allow for easier flipping.

PIÑA COLADA PINEAPPLE STICKS

Makes 6 servings

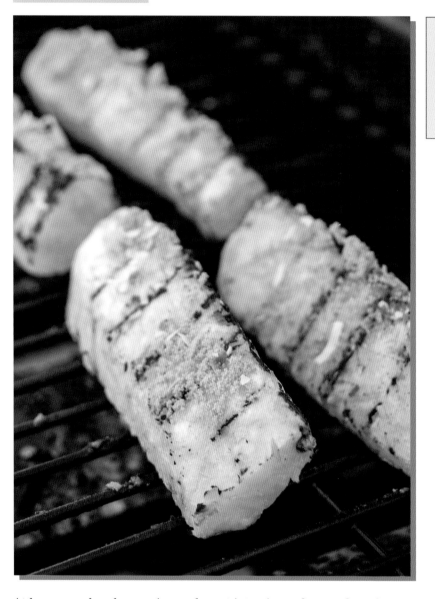

INGREDIENTS
- 1 pineapple
- 1 C. coconut milk
- Brown sugar
- Toasted coconut

At home, peel and core pineapple; cut into six wedges and put into a zippered plastic bag. Add coconut milk, seal the bag, and chill overnight. Grease the grill rack and heat the grill over campfire to medium heat; set the pineapple on the grill for several minutes on each side to get grill marks. Sprinkle with brown sugar and toasted coconut.

FIRECRACKER WATERMELON

Makes 4 to 6 servings

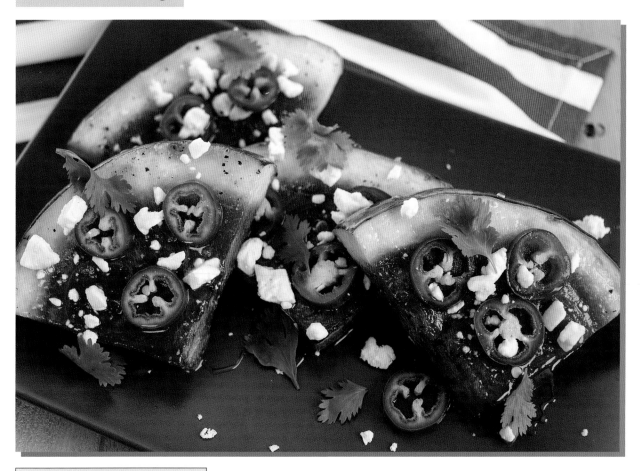

INGREDIENTS

- 1 mini watermelon
- Salt and black pepper to taste
- Lime juice
- Honey
- Jalapeño slices
- Crumbled feta cheese
- Fresh cilantro

Grease the grill rack and heat the grill or grate over campfire to medium-high heat. In the meantime, cut watermelon into 1"-thick slices; cut each slice into four even pieces and sprinkle with salt and black pepper. Set the melon on the hot grill rack and cook for a few minutes on each side until grill marks appear; set aside to cool slightly.

Drizzle the slices with lime juice and honey. Top with jalapeño slices, crumbled feta cheese, and fresh cilantro. Serve warm.

PEACHY MALLOW

Makes 1 serving

INGREDIENTS

- 1 peach
- 1 tsp. butter
- 2 tsp. brown sugar
- 1 marshmallow
- Ground cinnamon

Cut the peach in half. Remove and discard the pit. Cut one piece of heavy-duty foil large enough to wrap around the whole peach. Spray foil with nonstick vegetable spray. Set peach half on the foil, cut side up. Place butter in the hollow of the peach. Sprinkle brown sugar on the cut area of peach. Set one marshmallow in the peach hollow and sprinkle with cinnamon. Place the other peach half on top, with cut sides together. Wrap foil snugly around peach, sealing it well.

Place foil-wrapped peach on warm embers for 5 to 10 minutes or until peach is warm and marshmallow is soft. Move pack as needed to obtain even heating.

ROASTED PEACHES

Makes 1 serving per peach

Poke whole firm peaches with long campfire forks and roast them over hot coals until warmed through and juicy, turning often. Peel if you'd like, then slice and sprinkle with cinnamon-sugar.

INGREDIENTS

- Peaches
- Cinnamon sugar

GRILLED BANANAS

Makes 6 servings

Place banana halves (still in their peel) cut side up on a plate and drizzle evenly with honey. Sprinkle with brown sugar and transfer bananas to the grill, cut side up. Grill until tender, 3 to 5 minutes.

INGREDIENTS

- 6 firm ripe bananas, unpeeled and halved lengthwise
- 1/3 C. honey
- 3/4 C. brown sugar

FRUIT PUFFS

Makes 4 to 6 servings

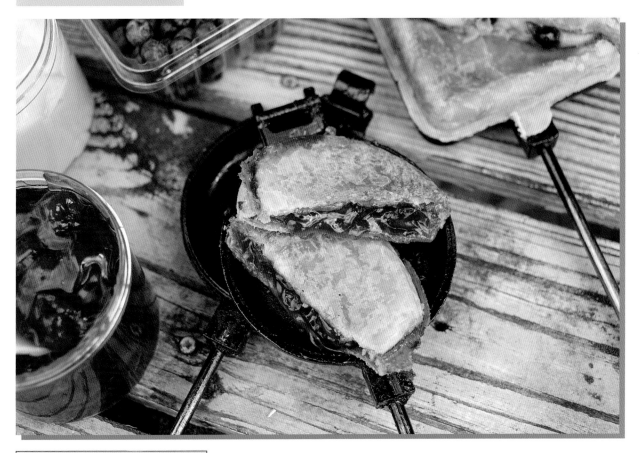

INGREDIENTS

- 2 frozen puff pastry sheets, thawed
- Apple, lemon, or cherry pie filling
- Raisins, blueberries, or white chocolate baking chips

Spritz pie irons with cooking spray. Press or roll puff pastry sheets until thin; cut to fit the pie irons (you should be able to cut four to six squares from each sheet). Position one square inside an iron. Put a big scoop of your favorite pie filling on the pastry, spreading out close to the edges. Add in a spoonful of extras if you'd like (try raisins with apple filling, blueberries with lemon, and white chocolate baking chips with cherry). Cover with another puff pastry square. Close the pie iron and cook over warm coals until the pastry is golden brown on both sides, turning occasionally. (Note: puff pastry expands as it cooks, so open carefully when checking for doneness.)

FRUITY BREAD PUDDING

Makes 4 to 6 servings

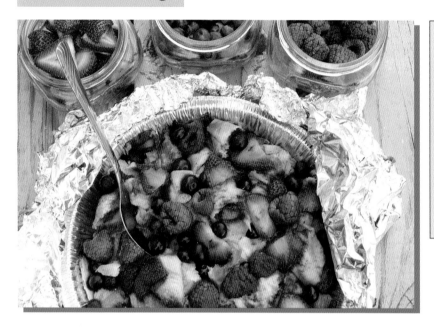

INGREDIENTS

- 3 large baked croissants
- 1 egg
- ½ C. milk
- ¼ C. sugar
- 1 tsp. vanilla extract
- ½ tsp. ground cinnamon
- Fresh berries, such as strawberries, raspberries, and blueberries

Tear croissants into bite-size pieces and place in a greased foil pie plate. Stir together egg, milk, sugar, vanilla, and cinnamon; pour over the bread and stir. Sprinkle berries on top. Set on a large piece of foil; bring foil up and over pie plate and seal edges.

Set in warm coals for 20 to 30 minutes or until bread is slightly crisp and all liquid has evaporated, rotating occasionally. Put a few hot coals on top of the foil toward the end of cooking to help crisp the top, if you'd like.

FOILED PEACHES

Makes 1 serving per peach

INGREDIENTS

- Butter
- Brown sugar
- Fresh peaches, halved, pitted
- Orange juice

Cut 1 tablespoon butter into small pieces and toss in the center of a large piece of heavy-duty foil. Sprinkle with some brown sugar. Set peach halves on the brown sugar, cut side up.

Top each peach half with more butter and brown sugar. Add about 2 tablespoons orange juice.

Fold up the foil, sealing all edges, and set on a grate above hot coals for 10 to 15 minutes. Rotate pack halfway through cooking time.

BACON-WRAPPED CANTALOUPE

Makes 6 to 8 servings

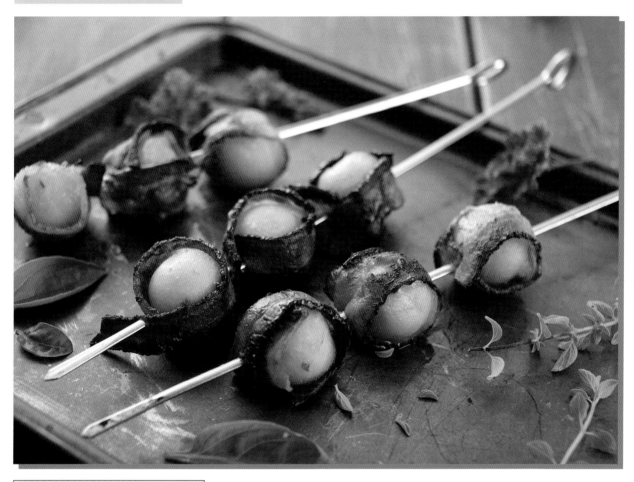

INGREDIENTS

- 1 cantaloupe
- 1 pkg. bacon

Use a melon baller to scoop the fruit from a cantaloupe. Partially cook one bacon strip for each melon ball, and drain the bacon on paper towels.

Grease the grill rack and heat to medium heat. Wrap a partially cooked bacon strip around each melon ball and slide onto skewers, securing the bacon to the melon. Arrange the skewers on the hot grill and let them cook for a few minutes on each side until the bacon gets nice and crispy.

PEARS IN CARAMEL SAUCE

Makes 2 servings

INGREDIENTS

- 2 T. sweetened butter
- 2 T. brown sugar
- Pinch of cinnamon
- 1 Comice or Anjou pear
- 1 orange, halved

Build a campfire. Set out two large pieces of aluminum foil. Cut pear in half and remove core and stem. In a small bowl, combine butter, brown sugar, and cinnamon. Lay each pear half on a piece of the aluminum foil. Scoop half of the butter mixture into the cored side of each pear. Squeeze orange juice over each pear. Wrap aluminum foil up around pears and seal tightly. Place wrapped pears directly in the coals of the campfire and cook for about 20 to 30 minutes, until completely softened. Using long tongs, remove packets from fire. Using a hot pad or oven mitt, slowly unwrap packets, being careful not to spill hot caramel sauce.

FRUIT PIZZA

Makes 1 pizza

INGREDIENTS

- 2 cans refrigerated crescent rolls
- 2 bricks cream cheese
- 2 C. powdered sugar
- 2 tsp. almond extract
- 6 to 8 C. chopped or small colorful fruit
- Chopped nuts (optional)
- Chocolate sauce

At home, grease large baking sheet. Arrange crescent rolls flat on sheet to form crust layer. Pierce with fork. Bake to desired crispness. Cool. Mix softened cream cheese with powdered sugar and almond extract. Spread over cooled crust. Mix fruit and nuts and spread over cream cheese layer. Cover with waxed paper sheet and press firmly. Keep cold. Cut with pizza wheel, and wrap pieces individually for easy packing in cooler.

At camp, drizzle with chocolate sauce and serve!

S'MORE BURRITOS

Makes 1 serving

INGREDIENTS

- One 8" flour tortilla
- 2 to 3 T. crunchy peanut butter
- 3 T. miniature marshmallows
- 3 T. miniature chocolate chips

Cut one piece of foil about 12" long. Set tortilla on the center of the foil. Spread the peanut butter over the tortilla, almost to the edges. Sprinkle the marshmallows and chocolate chips over half of the peanut butter. Fold in the sides and then roll up the tortilla like a burrito, beginning with the chocolate chip side. Wrap foil around burrito in a flat pack.

Place double-wrapped burrito on warm embers and cook for 5 to 15 minutes or until tortilla is warm and chocolate is melted. Move as needed to obtain even heating.

GINGERBREAD CAKE IN AN ORANGE SHELL

Makes 12 servings

INGREDIENTS

- One 14.5-oz. pkg. gingerbread cake mix (with egg and water)
- 12 thick-skinned oranges
- Caramel ice cream topping

At home, roll the oranges on a hard surface to soften the membranes inside. Cut the top fourth off each orange. Use a sharp knife to separate the pulp from the white membranes of each shell. With a spoon, carefully remove all the orange pulp without tearing the peel. Eat fruit or set it aside for later use. Prepare the cake mix as directed on package. Spoon batter into hollowed orange shells, filling each one about ⅔ full.

Cut one 10" piece of heavy-duty foil for each orange shell. Set orange in center of foil. Wrap foil up and around sides of shell, leaving the top open. Crimp foil around the top of shell and flatten bottom so orange stands upright.

At camp, place foil-wrapped oranges on hot coals for 15 to 25 minutes or until a toothpick inserted in cake comes out clean. Move them as needed for even baking. After baking, poke several fork holes in the top of each cake and drizzle with caramel ice cream topping. Eat warm with a spoon right from the orange shell.

ZESTY ORANGE S'MORES

Makes 1 serving per 1 graham cracker

INGREDIENTS

- Marshmallows
- Milk chocolate candy bars
- Orange zest
- Chocolate graham crackers

Toast marshmallow. Layer segments of milk chocolate candy bars, toasted marshmallow, and orange zest between split chocolate graham cracker.

STRAWBERRY CREAM S'MORES

Makes 1 serving per 1 graham cracker

INGREDIENTS

- Marshmallows
- Cream cheese, softened
- Fresh strawberries, sliced
- Cinnamon graham crackers

Toast marshmallow. Layer toasted marshmallow, cream cheese, and strawberries between split cinnamon graham cracker.

LEMON COCONUT S'MORES

Makes 1 serving per 1 graham cracker

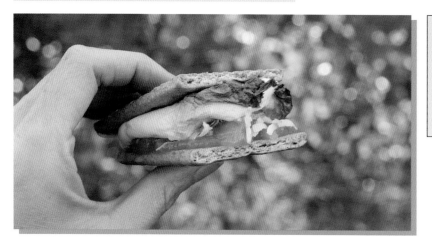

INGREDIENTS

- Marshmallows
- Lemon curd
- Toasted coconut
- Graham crackers

Toast marshmallow. Layer toasted marshmallow, lemon curd, and toasted coconut between split graham cracker.

CHOCO RASPBERRY S'MORES

Makes 1 serving per 1 graham cracker

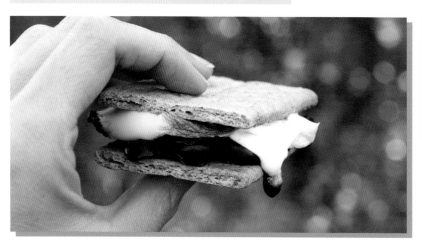

INGREDIENTS

- Marshmallows
- Raspberry jam
- Dark chocolate candy bars
- Graham crackers

Toast marshmallow. Layer toasted marshmallow, segments of dark chocolate candy bars, and raspberry jam between split graham cracker.

GRILLED CHERRY CHOCOLATE PIZZA

Makes 1 pizza

INGREDIENTS

- Half 8-oz. tub whipped cream cheese
- 5 T. sugar
- 1 sheet puff pastry, thawed
- Cherry pie filling
- Mini semi-sweet chocolate chips
- Chopped butter cookies or oatmeal cookies

Heat grill or grate over campfire to medium-high heat. Stir together cream cheese and sugar. Coat a large piece of foil with cooking spray and set on grill rack; unfold pastry on foil. Cook until bottom is golden brown and remove from heat. Flip crust; spread with cream cheese mixture. Top with pie filling and chocolate chips. Return to grill. Cover with foil or close grill lid; cook until bottom of crust is golden. Remove from grill and top with cookies.

CAMPFIRE CONES

Makes 1 serving per waffle cone

INGREDIENTS

- Bananas
- Strawberries
- Waffle cones
- Chocolate chips
- Mini marshmallows
- Nuts of your choice
- Any other toppings desired

Chop fruit into small pieces, then set out fillings for mix-and-match fun! Fill the cone nearly full with your choice of goodies, and wrap it all up in foil.

Set on a grate or lay in hot coals for a few minutes until marshmallows are soft and chocolate is gooey. Unwrap and enjoy!

CASHEW BROWNIE S'MORES

Makes 1 serving per 1 graham cracker

INGREDIENTS
- Marshmallows
- Brownie pieces
- Cashews, chopped
- Graham crackers

Toast marshmallow. Layer toasted marshmallow, brownie pieces, and cashews between split graham cracker.

BACON S'MORES

Makes 1 serving per 1 graham cracker

INGREDIENTS
- Marshmallows
- Crisp bacon
- Milk chocolate candy bars
- Graham crackers

Toast marshmallow. Layer toasted marshmallow, bacon, and segments of milk chocolate candy bars between split graham cracker.

APPLE PIE S'MORES

Makes 1 serving per 1 graham cracker

Toast marshmallow. Layer toasted marshmallow and apple slices between split cinnamon graham cracker.

STRAWBERRY NUTELLA BANANA S'MORES

Makes 1 serving per 1 graham cracker

INGREDIENTS
- Strawberry marshmallows
- Nutella or other hazelnut spread
- Banana slices
- Chocolate graham crackers

Toast strawberry marshmallow. Layer toasted strawberry marshmallow, Nutella, and banana slices between split chocolate graham cracker.

TROPICAL S'MORES

Makes 1 serving per 1 graham cracker

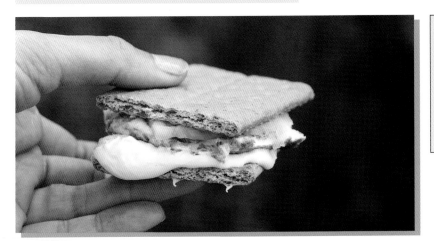

INGREDIENTS

- Toasted coconut marshmallow
- White chocolate candy bars
- Fresh pineapple slices
- Graham crackers

Toast toasted coconut marshmallow. Layer marshmallow, segments of white chocolate candy bars, and fresh pineapple slice between split graham cracker.

SAILOR S'MORES

Makes 1 serving per 2 crackers

INGREDIENTS

- Marshmallows
- Creamy peanut butter
- Milk chocolate bar
- Saltine crackers

Toast marshmallow. Spread peanut butter onto one side of each saltine cracker and place a segment of milk chocolate bar on one of the saltines. Place toasted marshmallow between two saltines.

FUDGY ORANGE CAMPFIRE CAKES

Makes 1 serving per orange

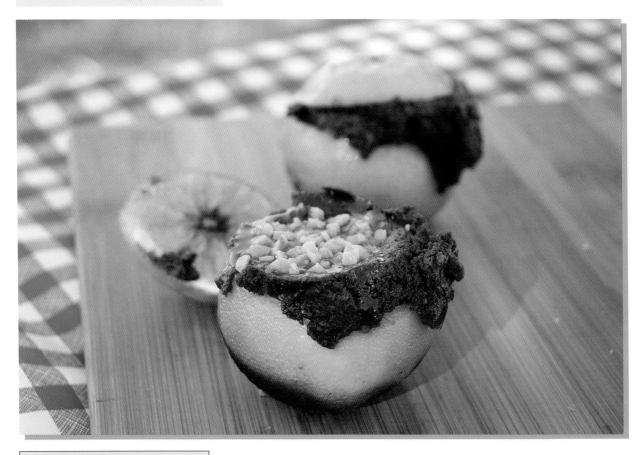

INGREDIENTS

- Oranges
- Your favorite cake or brownie batter
- Toffee bits, caramel sauce, or any other toppings desired

At home, slice off the top of each orange and hollow out the inside. Fill orange shells with batter to within 1" of the rim to leave room for expansion. Replace the orange top. Seal in foil and refrigerate.

At camp, place foil-wrapped oranges in hot coals for 20 to 30 minutes, keeping open end up. Remove with tongs, unwrap, and add toppings.

STRAWBERRY SHORTCAKES

Makes 1 serving per 2 cake slices

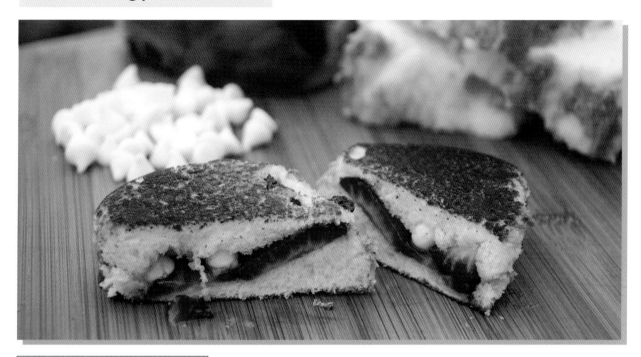

INGREDIENTS

- Angel food cake, sliced about 1" thick
- Strawberries, sliced
- White chocolate chips

Spray the inside of a preheated pie iron with cooking spray. Stack one cake slice, strawberries, white chocolate chips, and a second cake slice in iron, thick sides of cake on opposite ends.

Close the iron and hold over hot coals for a few minutes, rotating iron. These cook fast, so check often. Remove from iron and serve.

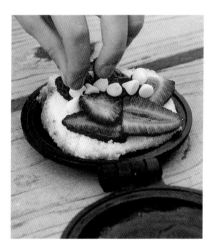

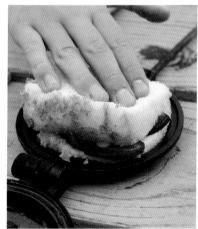

TOASTED COCONUT PUMPKIN PIES

Makes 1 serving per 2 bread slices

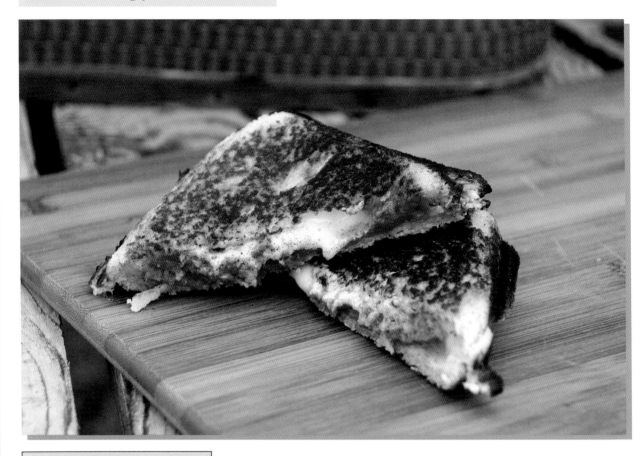

INGREDIENTS

- Butter
- Bread
- Pumpkin pie filling
- Coconut marshmallows

Butter bread slices; add one to hot pie iron, buttered side down. Add pie filling and a few marshmallows. Top with a bread slice, buttered side up.

Close the iron and cut off excess bread before holding in hot coals. Keep it in there for a couple of minutes on each side until the bread is nicely toasted, checking often.

LEMON-LEMON S'MORES

Makes 1 serving per 2 cookies

INGREDIENTS

- Marshmallows
- Lemon curd
- Cookies and cream candy bars
- Lemon cookies

Toast marshmallow. Layer lemon curd, toasted marshmallow, and segments of cookies and cream candy bars between two lemon cookies.

PARTY PASTRY S'MORES

Makes 1 serving per 1 toaster pastry

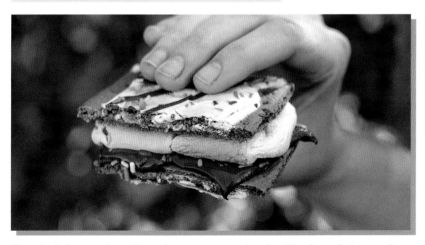

INGREDIENTS

- Pink marshmallows
- Milk chocolate candy bars
- Rainbow sprinkles
- Toaster pastries

Toast pink marshmallow. Layer segments of milk chocolate candy bars, toasted pink marshmallow, and rainbow sprinkles between a split toaster pastry.

CINNAMON SENSATION S'MORES

Makes 1 serving per 1 donut

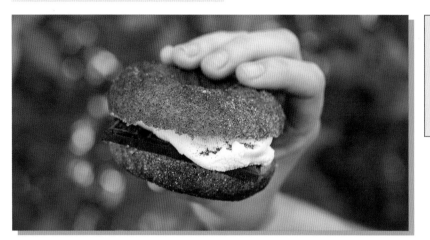

INGREDIENTS
- Marshmallows
- Dark chocolate candy bars
- Cayenne pepper
- Cinnamon sugar cake donut

Toast marshmallow. Layer segments of dark chocolate candy bars, toasted marshmallow, and a sprinkle of cayenne pepper between split cinnamon sugar cake donut.

MINTY MIX S'MORES

Makes 1 serving per 1 graham cracker

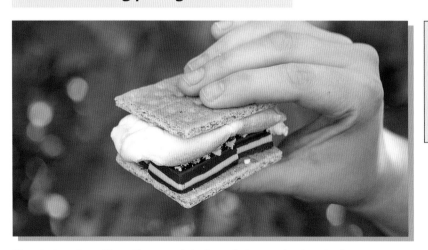

INGREDIENTS
- Marshmallows
- Mint chocolate candy
- Crushed peppermints
- Graham crackers

Toast marshmallow. Layer mint chocolate candy, toasted marshmallow, and crushed peppermints between spilt graham cracker.

GRAPE THYME APPETIZERS

Makes 6 to 8 servings

INGREDIENTS

- Purple seedless grapes
- Olive oil
- Salt to taste
- Dried thyme to taste
- Cream cheese, softened
- Crackers

Cut a couple bunches of purple seedless grapes in half and toss in a single layer into a foil pan. Stir in a little olive oil; sprinkle with salt and dried thyme to taste.

Set the pan on hot grill or grate for 5 to 10 minutes, until the grapes have softened a bit, stirring occasionally. Set aside to cool slightly.

Spread some softened cream cheese on your favorite crackers and top with a little scoop of grapes.

MUNCH MUNCH

Makes 6 to 8 servings

INGREDIENTS

- Salted pepitas
- Sunflower kernels
- Yogurt- or chocolate-covered raisins
- Dried fruit
- Unsweetened coconut chips, toasted if desired

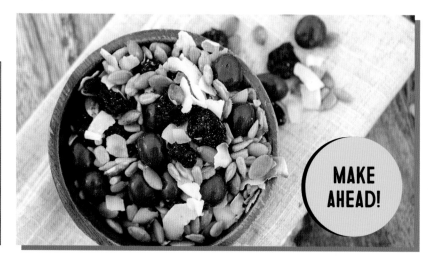

MAKE AHEAD!

Mix equal amounts of salted pepitas, sunflower kernels, yogurt- or chocolate-covered raisins, dried fruit, and unsweetened coconut chips in a zippered plastic bag or airtight container. Mix it up, take it along, and enjoy.

CHOCOLATE PEANUT BUTTER HUMMUS

Makes 6 servings

INGREDIENTS

- One 16-oz. can chickpeas, drained and rinsed
- ¼ C. peanut butter
- ¼ C. plus 1 T. maple syrup, divided
- ½ C. unsweetened cocoa powder
- 1 tsp. vanilla
- ¼ tsp. salt
- 2 to 3 T. water

At home, in a food processor, combine chickpeas, peanut butter, ¼ cup maple syrup, unsweetened cocoa powder, vanilla, and salt. Process for 30 seconds, then scrape down the sides of the bowl. Add water and process again until it becomes nice and creamy; chill.

At camp, set the hummus aside for a bit to soften, then stir. Drizzle with maple syrup and top with chopped peanuts. Serve with pretzels and fresh fruit, such as apples and strawberries.

ROASTED NUTS

Makes 4 to 6 servings

INGREDIENTS

- 2 C. salted mixed nuts
- 1 tsp. chili powder
- ¼ tsp. cumin
- ¼ tsp. black pepper
- Butter

Stir together nuts, chili powder, cumin, and black pepper; add a few pats of butter. Wrap in foil; cook in warm coals until heated, turning often.

CORN AND BLACK BEAN GUACAMOLE

Makes 6 servings

INGREDIENTS

- 1 Roma tomato, diced
- ½ red onion, diced
- 2 garlic cloves, minced
- 1 C. canned sweet corn
- 1 C. canned black beans, drained and rinsed
- 2 T. lime juice
- ½ tsp. salt
- ½ tsp. black pepper
- ¼ tsp. cayenne pepper
- ½ C. chopped fresh cilantro
- 3 avocados
- Tortilla chips

At home, in an airtight container, combine tomato, red onion, garlic, sweet corn, black beans, lime juice, salt, pepper, cayenne pepper, and cilantro; cover and chill.

At camp, peel, pit, and mash avocados to desired texture and stir them into the tomato mixture. Serve with tortilla chips.

PHYLLO BITES

Makes 4 to 6 servings

Fill mini phyllo shells with your favorite ready-to-eat filling, such as pudding, pie filling, or cheesecake filling. Garnish with fresh fruit or nuts if you'd like.

INGREDIENTS

- Pre-baked mini phyllo shells
- Pudding
- Pie filling
- Cheesecake filling
- Fresh fruit
- Nuts

CAST IRON NACHOS

Makes 6 servings

INGREDIENTS

- Tortilla chips
- Chili con queso cheese sauce
- Green onion, chopped
- Tomato, chopped
- Bell pepper, chopped
- Precooked taco meat
- Sliced black olives
- Your favorite shredded cheese
- Sour cream
- Salsa
- Guacamole

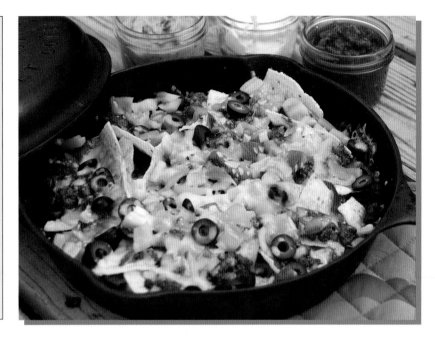

In a large cast iron skillet, layer chips, cheese sauce, green onion, tomato, bell pepper, meat, olives, and shredded cheese. Repeat layers. Set on a cooking rack over warm coals until cheese melts, covering with foil to help melt cheese, if needed.

Serve with sour cream, salsa, guacamole, and any other favorites.

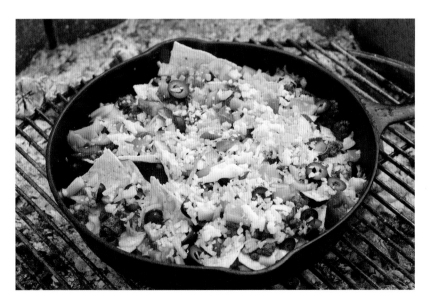

STUFFED BABY PEPPERS

Makes 1 serving per baby bell pepper

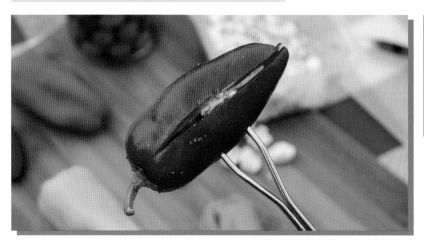

INGREDIENTS

- Baby bell peppers
- Salt and pepper
- Feta cheese
- Green olives

Cut a slit down one side of each pepper; remove seeds. Sprinkle the cavity with salt and pepper. Stuff full of cheese and olives. Poke a roasting stick through the side of the pepper, making sure it goes nearly through the other side. Keep rotating until the pepper is toasted to your liking. Peppers will blister when done.

FIRE-ROASTED PICKLE WRAPS

Makes 1 serving per pickle

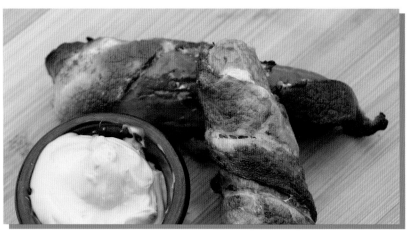

INGREDIENTS

- Bacon strips
- Whole dill pickles
- Cream cheese, softened

Push one end of bacon on a sharp stick. Add pickle and wrap with bacon, attaching other end to tip of stick. Use toothpicks to secure the bacon. Roast slowly over the fire until bacon is done and pickle blisters. Serve with cream cheese for dipping.

POPCORN PACKS

Makes 2 to 4 servings

INGREDIENTS

- 2 T. popcorn kernels
- 2 T. canola oil
- Salt to taste

Place popcorn and oil on an 18" piece of heavy-duty foil. Fold foil in half; double-fold the edges. Fold up sides to seal in kernels and oil. Leave some space in there for the popping corn.

Poke a sharp stick through the double folds and hold pouch over flames, shaking often. Continue shaking until popping slows. Let pack cool a bit before opening. Sprinkle with salt and enjoy.

MUSHROOM AND BACON BITES

Makes 4 to 6 servings

Heat grill or grate over campfire to medium heat. Wrap each mushroom with a strip of bacon; secure with a toothpick. Thread onto skewers; brush with barbecue sauce. Grill over indirect heat for 10 to 15 minutes or until bacon is crisp and mushrooms are tender, turning and basting occasionally with remaining barbecue sauce.

INGREDIENTS

- 24 medium fresh mushrooms
- 12 strips bacon, halved
- 1 C. barbecue sauce
- Skewers (wooden skewers soaked in water for 30 minutes or metal skewers)

INDEX

Note: Page numbers in **bold** indicate TOC lists of recipes by category.